The L Word

The L Word

A Photographic Journal

Jennifer Beals

PREFACE BY KARA SWISHER

weldon**owen**

For the fans, who inspire me.

PREFACE

"We are all one—and if we don't know it,
we will learn it the hard way."

—Bayard Rustin

It's fair to say every lesbian of a certain age remembers when they saw the first episode of *The L Word* in 2004, because it was also the first time that we got to see us as we were and, perhaps more accurately, as we might be. While our lives were not as glamorous as the endlessly intertwined denizens of West Hollywood, with their complex and dramatic narratives (and fantastic outfits, haircuts, and jobs), in them we could begin to imagine versions of ourselves who could hang together or fall apart. More importantly, through them, we were people who demanded to be seen.

It was certainly hard to look away from the characters created by Ilene Chaiken—from the commanding elegance of Jennifer Beals' Bette Porter to the whimsical charms of Alice Pieszecki, played Leisha Hailey to Kate Moennig's mic-drop of a hairdresser Shane McCutcheon. And so many more astonishing women over the years, who entered and exited the *L Word* story over six seasons on Showtime to leave behind little bits of memories, shards of broken hearts. And, yes, a lot of laughter too.

As a writer, even if you had quibbles with the sometimes-over-the-top lines or plot ("WHAT did she just say?!?"),

it was invigorating to have the center of the action be the queer women, who had long been relegated to the sidelines as props, often pathetic or comical or, mostly, just invisible. Sure, Ellen DeGeneres had broken the silence in 1997 with her groundbreaking "I'm gay" words on her eponymous sitcom, but the truth is that she didn't really do much to be gay after that. Only a few years later, *The L Word* took that idea of "we're here, we're queer, get used to it" to a quantum level higher. We were not just here and queer, we were inevitable and, hands down, superb.

It was in those years that I was lucky enough to meet Ilene, Jennifer, Kate, and Leisha and I had the privilege of watching their progress in real time and on the set in Vancouver, relationships that have lasted until this day. I think they never thought of themselves or the show as a groundbreaking and brave and pioneering effort in modern television, but simply a group of creators trying to tell a really good story. What was amazing about it was to see them each develop and grow, both in real life and in *The L Word* world. Me too, getting older, having kids, getting married, getting divorced, getting married again, having more kids, not unlike the

characters on the show, though decidedly less sexy.

The world had also changed inexorably too, as digital slowly and then all at once started to devour everything in its path, including Hollywood. I remember telling some of the cast, as we hung at a restaurant in San Francisco, about how a spate of new services like Twitter and Netflix would amplify what they were doing, but also flood the zone with all kinds of stories of all kinds of lives. But when I tried to sign Jennifer up for a Twitter account, she grokked then what is clear now: "Why would I want to live in just 140 characters."

Why indeed, because those kinds of bits and bytes sail by and are gone in an ever-fleeting flash these days. Which is also why her collection of personal analog photographs, along with both laugh-out-loud and tear-jerking interviews, chronicling the intimate moments from a monumental point in lesbian history is so important to pay mind to and to treasure. They tell the tale of a moment in time in which we were all one and we knew it. And, of course, when *The L Word* gave us the priceless gift of seeing each other ■

—Kara Swisher

FOREWORD

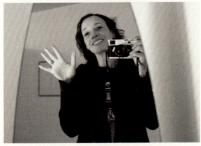

In celebrating twenty years of *The L Word*, it is with love I present to you *The L Word: A Photographic Journal*, replete with memories in the form of analog photos, interviews, and treasured ephemera. This book had its first life twenty years ago as a wrap-gift to the beloved cast and crew with whom I shared indelible experiences during our countless hours on and off set. As I open this up to share with the world, all these years later, I only hope this collection of photographs, and the interviews paired alongside them, will provide an understanding of how much this show meant to us, and serve as an entree to the behind-the-scenes moments that informed the fictional friendships aired each Sunday night.

In a lifetime, there are moments that, in retrospect, appear as markers. At the time, you don't experience them as "defining moments." But as you look back years later, they light up and you realize that not only were you in the midst of your own defining realizations, you were in the midst of a tectonic cultural paradigm shift.

I thought I was just making a show.

At best, I hoped *The L Word* would help some young, queer girl in the middle of nowhere who had never seen herself represented on mainstream television experience her own beauty and power. I had hoped our stories, created by showrunner Ilene Chaiken, would give that young girl a lifeline to her community, even if it was through fictional characters. I had no idea that there would be worldwide watch parties, where women would gather to enjoy the show in community. I had no idea girls would watch the show late at night from under blankets in the safety of their bedrooms away from their parents' prying eyes, trying to parse out their own identity through the lens of the show. I had no idea that twenty years later, a new generation would forge a decisive cultural transformation, demanding to be defined on their own terms, and that many of the members of this generation would reference *The L Word* as a piece of pop culture that helped them see themselves authentically rather than through someone else's eyes. This new generation forced Language to change in order to accommodate their experience of themselves. If that's not the highest form of heroic badassery, I don't know what is.

I have learned so many things from *The L Word*. First and foremost, I have experienced the power of storytelling. We are constantly surrounded by a swirl of stories that tell us who we are and what we are capable of. These narratives, including the ones we tell ourselves, inform us about our place in the world. Some of those stories come from our families ("she's the funny one," "he's the smart one," "not beautiful but you should hear her sing!"), our teachers ("if only he made more of an effort," "what

a joy it is to have her in class!") and our community writ large in mainstream media. But what story do you tell yourself if you never see yourself represented on screen? Or if and when you do, it is consistently as a sidekick or villain? Who are you if you are never at the center of the story?

To be at the center of the story can be a powerful thing; it gives a palpable agency to your life. As a young girl deep into Greek myths, I begged my mother to put me in whatever bedtime story she told me. After internalizing the story of Atalanta, later that week at school, I crushed our recess fifty-yard dash, leaving everyone—including a cocky middle school boy—in my dust.

The L Word was a very different type of project for me. There was the luxury of mining a character for six years and discovering new pockets of understanding as time went on; there was the community we created on set— a disparate bunch bound by our commonality of the Story and our dedication to telling that Story as honestly as possible. And there was, in the end, a bond created with our viewers in the broader LGBTQIA+ community,

the majority of whom had yet to see this aspirational aspect of their identity represented on mainstream television. Amidst all this, there was also a certain sense of responsibility to this role; as we started rehearsals, I knew this story was important in a way that perhaps other stories I had been involved with were not. I felt a duty and privilege to be as honest and as specific as possible with my character, Bette. The humanity of this show mattered to me. I am by nature a hermit, but I, who so cherished my solitude, far away from any crowd, would be led to the desire to use my voice to make an impact and stand for change.

Funny things happen when you play a character. Sometimes they ask you to become a bigger, more ferocious version of yourself. As I prepared to play Bette, it didn't feel like I was offering her my voice; rather, it was she who offered her voice to me, insisting I hurry up and start asking myself questions, the first being, "What is the nature of Love?" "Who gets to love freely?" "How do you find your voice?" followed closely by, "How do you then use that voice effectively?" Early Bette was not

the most patient soul. She needed me to get with the program so her story could be told.

In many regards, Mia Kirshner served as a role model. I watched her explore the humanity of her character, "Jenny," not trying to make her pure or good. Mia had no trouble using her voice on behalf of her character or elsewhere in her passionate activism and work with charities. Her example opened me up to the possibility of working in various ways to get to my own heart of the matter.

As Ilene's stories from *The L Word* went out into the world, we heard back from hundreds of viewers. We heard from hetero women who gloried in the powerful stories of female friendships, but overwhelmingly we heard how, by witnessing these stories, some people were encouraged to come out to their parents, their friends, and their coworkers, to be their most authentic selves. As I read and listened to their stories, their courage inspired me to be my most authentic self, and this hermit self was emboldened enough to emerge from the cave

of my own contentment to speak on behalf of others.

Portraying Bette deeply affected how I experienced the world. Not only did inhabiting her strength for six seasons lead me to play a series of other indomitable characters on film and television, the role of Bette Porter was an essential ignition to my activism. Since then, I have found myself standing up and speaking on behalf of others, whether they are LGBTQIA+ students advocating for safe and supportive school environments, servicewomen and men who have been sexually assaulted by their colleagues, or men, women, and children who have been exposed to toxic chemicals daily because their local government values big business over public health. When I am in these situations, and I start to feel intimidated or afraid, I sometimes summon Bette. Through this cherished character, and this community of people who have decided to use their voices either quietly or thunderously to speak and live their truth and to tell their stories, I find my own courage.

When just one person embraces authenticity, it gives the group the ability to do the same. Being an ally to the LGBTQIA+ community has taught me not only the power and succor of fellowship, but that doing what is right and speaking the truth is much more important than being comfortable or being perceived as agreeable. So, thank you to all our viewers who shared their stories with us, the cast and crew. As is so often the case, the Story helped create change for all of us, including me, in a very personal way.

It's been twenty years since *The L Word* aired its first episode, and the ground on which we stand as a society has shifted significantly since that journey began, much to the ontological fear of the minority. As I reflect on some of the episodes with the benefit of time, context, a new-and-improved lexicon and perhaps a modicum of wisdom, it is more than fair to say we did not always get those stories right. Today there is an abundance of knowledge and language surrounding sexuality and gender identity that in the early 2000s either had not been imagined or was not nearly as accessible and widespread as it might have been. I am immensely grateful for the understanding and clarity that time has given me as an ally. In another twenty years, perhaps we will look back at this present time with ever-increasing clarity and understanding.

It's interesting to note that despite its success, nothing has taken *The L Word*'s long-running place, in terms of a lesbian-centric show that tells the honest story of women living their lives freely and authentically. Ten years after the original went off the air, *The L Word: Generation Q*, like the original in its time, took us away not only from a heterocentric world but toward a more inclusive queer community. Those new stories of queer life had space to flourish briefly for three seasons.

Clearly, the queer community is not a monolith, it is heterogeneous in myriad ways. Were we able to tell every story? No. Those beautiful stories are revealing themselves at an exponential level no mathematician or poet could quantify. Like the original, *The L Word: Gen Q* was imperfect, but it dove into the swirl of stories growing around us and tried to enrich us all with new narratives.

At their center, the stories are always about love. Love and sexuality, whether in existence or in absentia, will always be the most intimate marker of who we are both individually and collectively. The "L," after all, also stands for love.

Years ago, I learned the derivation of the word "courage" comes from the French word, *cœur,* meaning heart. Courage originates in the heart. Which one of you will now take up the mantle and continue telling the tales, changing the narrative? Who will be the next courageous storyteller to pick up the "talking piece" and use their voice on behalf of others? As my high school adviser Marie Stone used to say, "If not you, then who?"

It is with the utmost gratitude and humility that I share this book with you. Thank you for letting me be part of your journey.

Courage.

—Jennifer, October 2024

INTRODUCTION

In 2002, nine actors arrived in Vancouver to become part of the cast of *The L Word*. Six of us would remain for the series' six-year run. Initially we arrived as separate individuals, but as we stepped onto our shared path we realized very quickly we were joined together by our experience as actors, and as women. We were connected too by a myriad of things we could not see—intuition, hope, love, pain, fear, courage. All of these silent ties bound us together, and as painful or joyous as they might have been to acquire during our lifetimes, each was like a jewel we brought to our collective Hope Chest, and each of these jewels would indisputably be needed to serve our common purpose: The Story.

To give yourself fully to storytelling is nothing short of transformative. The leap requires faith in those things you cannot see but know are true. In this case the story and the leap of faith it required transformed a group of strangers into friends and then into family. Through storytelling, a community was formed.

Sometimes the story itself informed who we were as people. The Story itself was like a manifest, unnamable force that weaved its way through the hair and makeup trailers, onto the set, and sometimes back home again. The narrative at times made us stronger, kinder, and more forgiving. At other times, the story could make us closed off or even petty. Through it all we became closer.

There were times we worked hard at shaping the stories themselves: Ilene Chaiken, the series creator and showrunner, kept her door open to the cast and listened to our ideas—some were incorporated into the show, some were not, but our thoughts were always considered, and that made all the difference.

During the six years we were shooting *The L Word*, I kept a photographic journal of the cast and crew, motivated by a profound desire to create a bulwark against my rapidly eroding memory. It was an era of my life I was eager to preserve: I wanted to remember the cast, the read-throughs, the dinners, the rehearsals—everything. I took pictures and saved my scripts, call sheets, and memos, and organized them every year. I used them for reference as the seasons moved on; but frankly, I held onto them because I knew

I would get a kick out of looking at them as the years passed. I wanted to remember the joy, because no matter how dark the show's storylines got, we always managed to have fun.

These photos—taken over the six-year span of the show, some haphazardly, some with clear intention—give a glimpse of our time together. They offer a tiny window into how we became a family, chronicling part of our life at work, at dinners, at home, at award shows, and for me, most importantly, at the "circus"—the gypsy camp where our trailers were huddled together. The circus was the starting block, the place where we got ready with hair, makeup, and wardrobe. It was also where we rested, ate, worried, sang, played practical jokes on one another, fought, congregated over the latest who-knows-what, had Magus card readings, walked our dogs, chanted, laughed until we cried, and later on, where some of us ran back to care for our children.

There are so many people who were absolutely integral to our experience of the show who are not represented here and to them I apologize. I wish I had spent more time interviewing the cast,

and taking more photos, but there were times I needed to put the camera down.

There are many people I would like to thank for helping me create this journal: the book's designers, The Goggles—Paul Shoebridge and Michael Simons—who kept me going with their ideas so quickly manifested; everyone at DigitalFusion, particularly Samantha Turchin, John Supra, Christina Olsen, Kathryn Sands, Michael McHugh, and Hugh Milstein, for their care and generosity. Thank you to everyone at Showtime, past and present, particularly David Bowers, Faye Katz, Howard Sherman, Gary Levine, Jerry Offsay, Matt Blank, and Bob Greenblatt, for their constant support and encouragement. To ColorCentric and Kodak, for their generous donation of time and expertise. To Annabeth Rickley, for tirelessly helping me with the transcripts; my editor, the intrepid, indefatigable Kera Bolonik, who helped guide me; my friend and publicist David Lust, my inexhaustible voice of encouragement and reason; my family, for their love and support. Forever my gratitude goes to Ilene Chaiken, who kindly invited me into her stories week after week and who answered my endless texts about episodes and various ephemera. And to the cast of *The L Word*: Laurel Holloman, Kate Moennig, Leisha Hailey, Erin Daniels, Pam Grier, Sarah Shahi, Daniel Sea, Marlee Matlin, Rachel Shelley, Rose Rollins, and Mia Kirshner, for their encouragement, patience, stories, and friendship, I am forever indebted.

Years ago, I started a tradition of making a photo book, to give as a gift to the cast and crew, after completing projects that were near and dear to my heart. As I started working on my cast-and-crew present for *The L Word*, I realized this wouldn't be like the others. *The L Word* was, among many things, about the power of storytelling. Clearly we were telling Ilene's stories, but we were also telling our stories, the story of a group of colleagues who evolved into a family while endeavoring to do something worthwhile. And in many ways, we were telling the viewer's stories. And the notion that we were part of a narrative where we could offer up some sort of mirror, however imperfect, to someone who may never before have seen themselves represented was very exciting to us all. To know that you exist is validating, but to then see how you exist within a broader, beautiful context, and then finally to know that we all exist as one larger, extended community is an extraordinary concept to fathom—extraordinary and ultimately fulfilling. One of the greatest accomplishments of *The L Word*, I think, is that it elucidated the connections between us all, demonstrating the ways in which we belong to the family of humanity. It certainly did this for us as cast members. More profoundly, as we learned over the years, *The L Word* did this for viewers around the world ∎

—Jennifer, 2010

Earthlings by Ilene Chaiken

Buff Pages August 12, 200
Salmon Pages August 1, 200
Goldenrod Pages July 26, 200
Green Pages July 24, 200
Yellow July 22, 200
Pink Pages July 17, 200
Blue/Final July 15, 200
White July 06, 200

Executive Producer: Ilene Chaiken
Executive Producers: Steve Golin
 Larry Kennar
 Kathy Greenberg
 Michele Abbott
Producers: Rose Troche
Director:

3 INT, BETTE & TINA'S HOUSE - BAT

season 1

Against a backdrop of original
wearing a pajama top, no botton
test stick. As she paces, a pin
box. Tina sees it, clenches her
of triumph.

 TINA
 Honey, today's the da

BETTE CORTESI enters the bathro
pajamas. Bette comes up next to

 BETTE
 Excellent. You're ovu

Bette slips in between Tina and

 BETTE (CONT
 Let's make a baby.

Bette unbuttons Tina's pajama t
Tina arches into her.

 TINA
 Let's... make a baby.

Bette bites Tina's earlobe, pul

ROOM - SAME 3

t-deco tiles, TINA KENNARD --
-- pees onto an ovulation
"X" slowly appears in the
ist in a contained gesture

in her elegant men's *
ina to examine the stick.

ting.

he sink, kisses her.

D)

and pulls her in close.

her hair and holds her

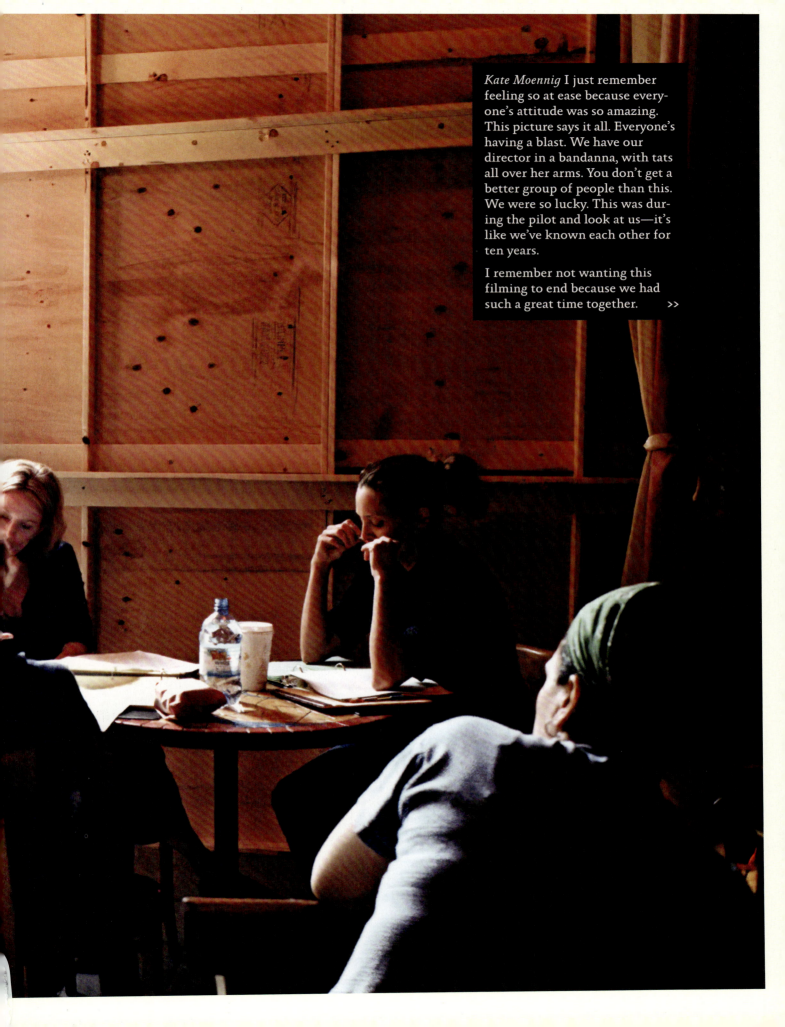

Kate Moennig I just remember feeling so at ease because everyone's attitude was so amazing. This picture says it all. Everyone's having a blast. We have our director in a bandanna, with tats all over her arms. You don't get a better group of people than this. We were so lucky. This was during the pilot and look at us—it's like we've known each other for ten years.

I remember not wanting this filming to end because we had such a great time together. >>

Erin Daniels [About the first rehearsal] I just remember thinking, "Don't fuck up." I was still nervous that I was going to lose the job, even though we were rehearsing. I thought I could always be replaced [laughs] because I had a hard time getting the job. I don't know if you knew this, but they tested me for Dana and then they asked me if I could come back a week later and test again and they were going to find all new people for me to test against and I said, "No. I'm not going to do it. I'm DONE. I don't want to jump through hoops." I was back in school for design at that point. I was like, "I don't want to do T-H-I-S." And then [sigh] Beth Klein, who is a really good friend of mine, an old friend of mine, she called me, and she was like, "Please, PLEASE just come back, PLEASE!"

And I said, "I can't believe you're abusing our friendship like this, but I will." And so of course I went back and I got the part but I felt I really had to prove myself. And so at that first rehearsal and at the first table-read, I remember thinking, "Don't fuck up."

Jennifer Beals And of course all the brass was there at that first table-read.

Erin I was SO nervous. But I got a nice compliment from Gary Levine [our producer from Showtime] after the table-read so I felt a little bit better . . . and then at the first rehearsal I was just still thinking, "Be funny," "Be good," "Don't mess up," and "Be relaxed," of course [they both laugh].

Meanwhile I'm nervous but I remember it being really fun. I knew from before that first >>

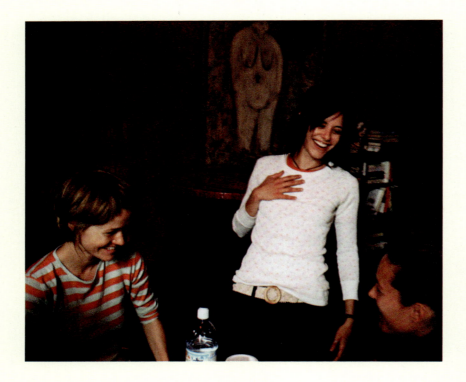

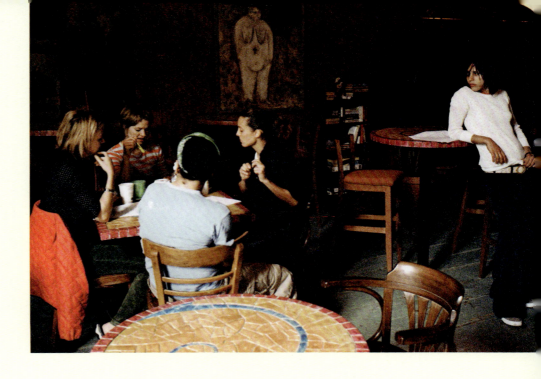

« rehearsal, that Kate, Leisha, and I were like the Three Musketeers. It began before we even started rehearsing. It started on the plane with Leisha. We met standing in line to get on a plane, and then we were like best buddies. I get sick on the plane—not a good flier—and I was like, if I can get through this with somebody who won't judge me, then . . . Leisha and I were buddies by the time we landed.

Laurel Holloman The only thing I remember about the first rehearsal was that I just prayed that I wouldn't get fired. I usually feel that way on every job. It's good because it makes me work harder. Also I was like, wow, it seems that Jennifer and I made a very relaxed couple and we basically just met.

Leisha Hailey Oh, I've never been so panicked in my life. I think my personality split off into like some other person so I could handle the nerves that I was experiencing because I didn't know what I was doing. I was like, "Why am I here? What does this mean, and how does this go?"

I had never been on TV before so I was basically—my whole idea of what to do to get through it was just to sit back and watch people and learn.

Jennifer See, you seemed so relaxed to me, like you were having a great time. My experience of the first rehearsal was everybody else was so relaxed having a great time, and I was having the panicky feeling. I didn't know anybody, and I was in that realm of uncertainty where you don't know who the character is just yet.

I was so thankful to have my camera there just to ground me ∎

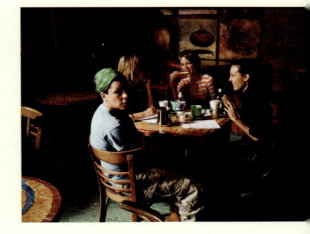

19

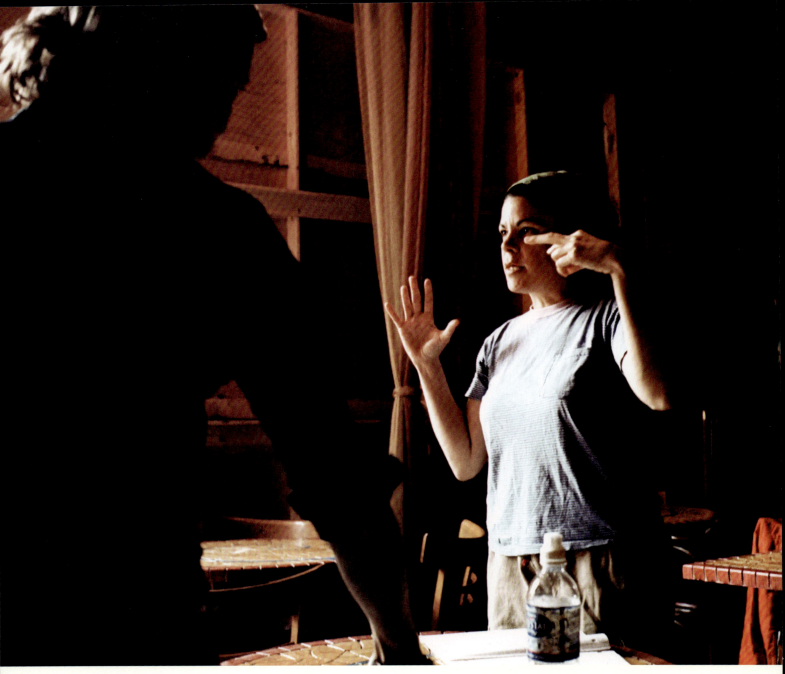

ROSE TROCHE

Kate Rose is constantly gesticulating and making a joke. She gets all stressed out, but she still can find the humor in anything. I just love Rose. I love her direction. She was so invested. I just felt like we were making something special when we shot this. I felt so excited and so honored that I was in this thing ∎

Jennifer There's Ilene with long hair.

Leisha That is so crazy! She looks like an earth mother.

Mia Kirshner Oh my god. Like she would have a house up in, you know—where?

Leisha Big Sur.

Mia Big Sur.

Jennifer Ojai.

Mia Oh my God!

Leisha That's exactly how I remember her in the auditions. I thought to myself, "Aww, this little lady is so sweet."

Mia Yeah.

Leisha And timid.

Mia Yeah, that was my impression.

Leisha Like, your heart broke for her, "Aww. Is she gonna be able to handle all of this?" Like, the little nerdy writer who got a show.

Jennifer I remember her from our first meeting as being very focused and determined. She was like the distillation of a writer—very observant and open. Clearly she had a will of steel just to be where she was. It was amazing really how much she included us in her process.

Kate This is insane. She looks like a lesbian fiction writer. Who probably grows her own beans in her garden.

Jennifer She looks like a little kid. She reminds me of Tallulah [Ilene's daughter].

Kate I remember standing at this bar. I think it was like my first or second day of work, taking a drink, and they gave me real hot coffee and I spit it all over the place because it was so hot.

Jennifer Nice ■

ILENE CHAIKEN

Jennifer Remember, the first year, they gave script notebooks to us. I think they gave us all notebooks, and that's how I got the idea of organizing and storing all my scripts over the seasons.

Leisha Wait, some of us didn't get them because I remember going to the office supply store with Erin and we bought tabs and notebooks.

Jennifer Are you sure?

Leisha Yeah, and she taught me how to break a script down. Positive. It was on 4th Street.

Mia You guys had all these experiences in the pilot that you and I, well I'll talk for myself, that I was not part of.

Jennifer Like what?

Mia I felt like I was doing my own show. Not that it was my show, but I was—I didn't go out with you guys at all.

Leisha I remember seeing you in the lobby of the Sutton Place, and then we asked you out.

Mia And what did I say?

Leisha "Oh no, that's okay. Thank you."

Jennifer No, "I'm going to Paris."

Mia No, thank you? Did I really say "No thank you?"

Leisha eah, you were very—like, you put your hand on your chest, and you were like super-shy ■

Leisha You guys think we were way more social than we were—mostly I was in my room all alone. I brought my little portable recording situation. And I would stay in there all day and write music. My first interaction was with Kate. I saw her in the gym—I was on the treadmill, and she looked over and said, "Cool T-shirt." I didn't quite know what to do. I think I pretended to lift some weights or something after that ■

KATE, ERIN, JENNIFER, AND LEISHA AT DINNER. THE SUTTON PLACE HOTEL

Erin [to Jennifer] I remember how shy you were.

Jennifer God, it was so excruciating when I would hear you guys would get together, and I was like the loser in my room [laughs].

Erin That's so funny. Well, we were shy, too. The funny thing is we were all intimidated by you, of course.

Jennifer But WHY? I didn't do anything that was particularly intimidating.

Erin You just were who you were and we were all like [whispers], "She's like the star. Who's going to talk to her? I don't know—you call her." There was this whole conversation one night and I called you. [laughter]

Jennifer I remember I was so GRATEFUL.

Erin Oh my God, it was so funny.

Jennifer I was wondering when is anyone going to call me? I wanted to come hang out, but honest to God, I was too afraid to say can I come hang out with you, because that would be so lame. I remember calling my friend Elizabeth Berkley and saying this feels like a high school I never went to.

Erin WE were afraid, too—we were just like, "Who's going to call her? Kate, Leisha, Mia . . . and I was like, "Give me the phone."

Jennifer You were Julie, the Cruise Director.

Erin I was ■

Kate We're all actors, but nobody acted like "actors," in that stereotypical way. We cared about the work and making the scenes the best they could be, but it ended there. We didn't get into all of that business-talk bullshit. That was the last thing any of us would talk about. Even when we were about to go on hiatus, no one ever tried to one up each other. We just enjoyed each other's company so much that we always had so many other things to discuss or gossip about.

Jennifer Everybody was so different. For me, it felt like the Fantastic Four where everybody had their own superpower.

Kate Oh—totally!

Jennifer Everybody in the cast had their own, very specific gifts to bring ∎

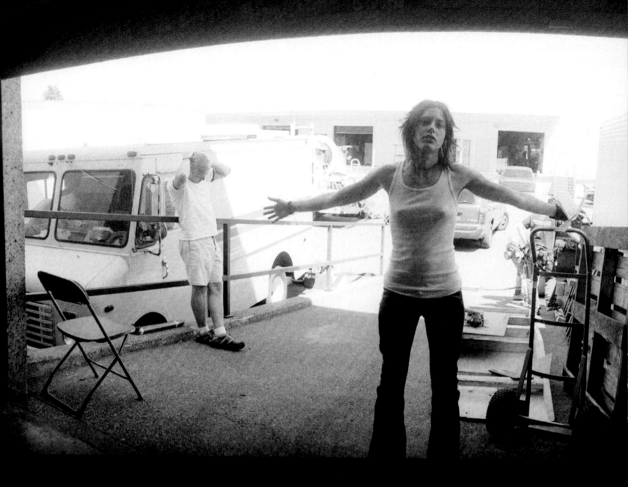

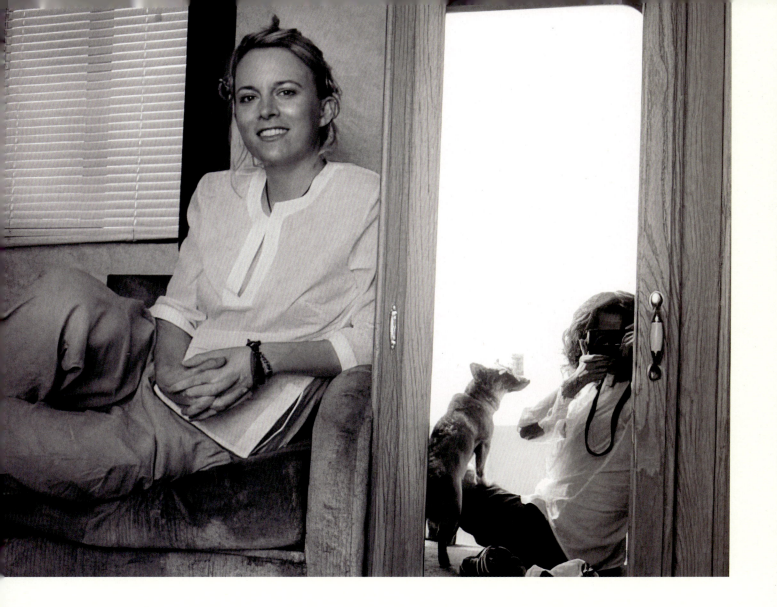

Laurel It always took me so long to make my trailer homey. I usually just threw a yoga mat in it. I remember walking into Erin Daniels's trailer and she had transformed it into a five-star hotel with perfect cashmere throws and candles. Also Mia's trailer was next to mine and it was also cozy like a casbah love den with great candles. Later, after having kids, my trailer just became a playroom crowded with toys ∎

ERIC MABIUS

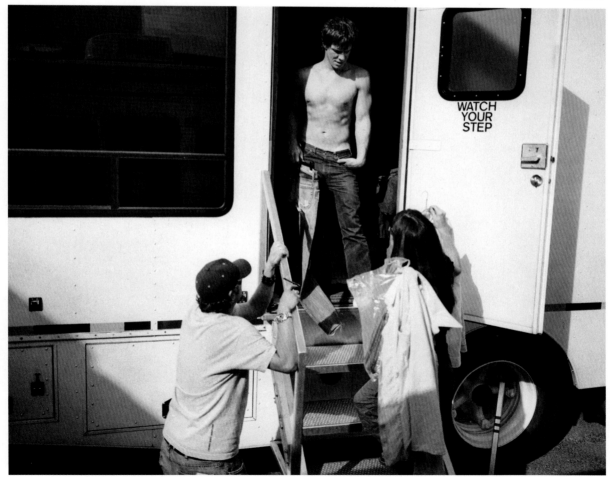

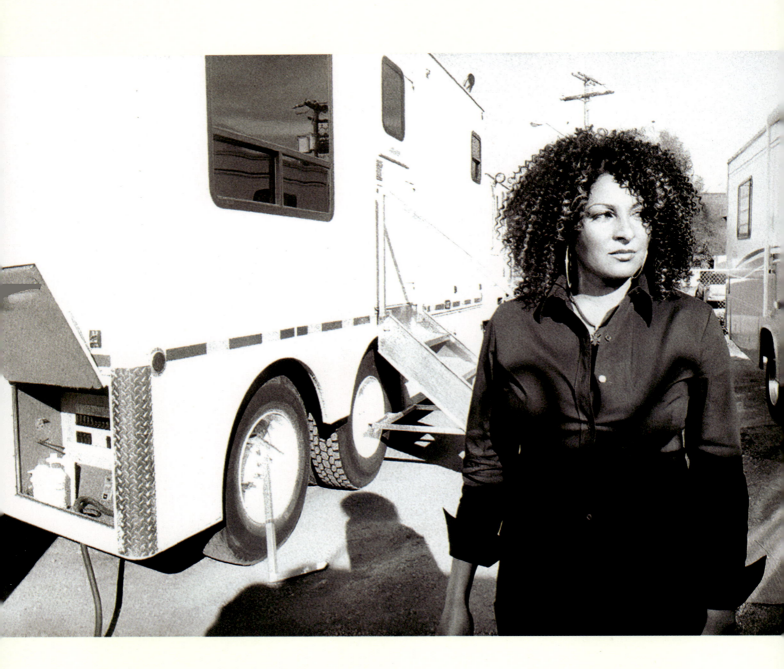

Pam Grier I don't know who was the culprit for suggesting me to play Kit, but I owe them so much gratitude for forming a rich and complex character to explore and give Bette a headache once in a while ∎

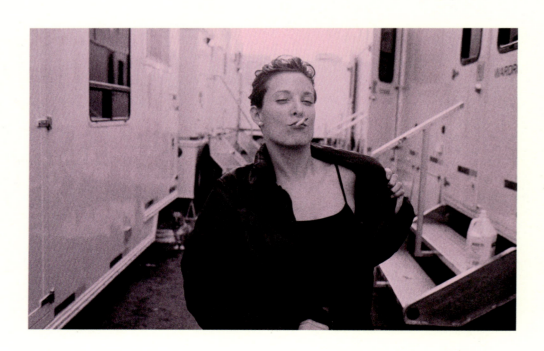

Erin [On her trailer] I always brought a candle. A scented candle.

Jennifer Did you subsequently during the season decorate your trailer?

Erin I didn't really DECORATE IT, but I always had a scented candle in there because trailers always have this smell, y'know? They used all these cleaning fluids that just smelled bad so I would always have scented candles in my trailer. But not the super-sweet kind, y'know. Something spicy.

Jennifer Would you bring your own linens?

Erin I did. I did bring my own linens. I brought sheets and I brought blankets and a couple of pillows so if I wanted to nap I didn't feel like I was napping in the heebie-jeebies.

Jennifer You know your trailer is described by other people as being the Spa Trailer.

Erin [laughs] Oh really? It was always clean. I'm totally anal retentive so my trailer was very clean and I always had scented candles—and lighting.

Jennifer What do you mean?

Erin Well, I bought a light.

Jennifer You bought a LIGHT?

Erin I know, but because the light in the trailers is terrible. So I bought this light that I hung from . . . I always brought lights or candles because the lighting is so harsh in trailers. But, yeah, in one of them I hung a light like this sweet little hanging light from a hook and somehow I jerry-rigged a hanging light in my trailer and it was super, it was really chill because of that.

Jennifer What about pictures?

Erin I think I did have a couple of pictures. I'm sure I had a couple of pictures of Paris up. I was such a Francophile. It's so funny. Still am. Don't know why I'm referring to it in the past tense. And I always had music. It was never the hippest music out there; it was always—I called it pretentious French music to go with the French thing. It was like all of those Coast CDs and all the mixed CDs of ambient electronica. [laughter] It was so funny. It was relaxing. It was comfortable. It was always really clean ∎

Mia I used to think of the first day at work like the first day of school. I had my little bag packed with all the supplies I'd need to make this room feel like a little home even though the interior-design choices—formica, beige, floral, plastic gold knobs—appeared to win over any of my attempts to silence them.

In the beginning seasons, it was pictures that I had taken on my travels for *I Live Here* (Mia's book, published in 2008). There were candles, music, special soaps, body lotions, craft projects, dog treats and toys, incense, flowers. In later seasons, my room became simple with just one or two illustrations on the wall and stuff for Rainbow, my dog. I always felt that the paring down of the room reflected my own feelings toward and distancing from the show ∎

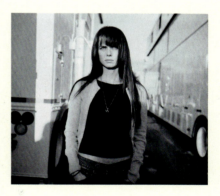

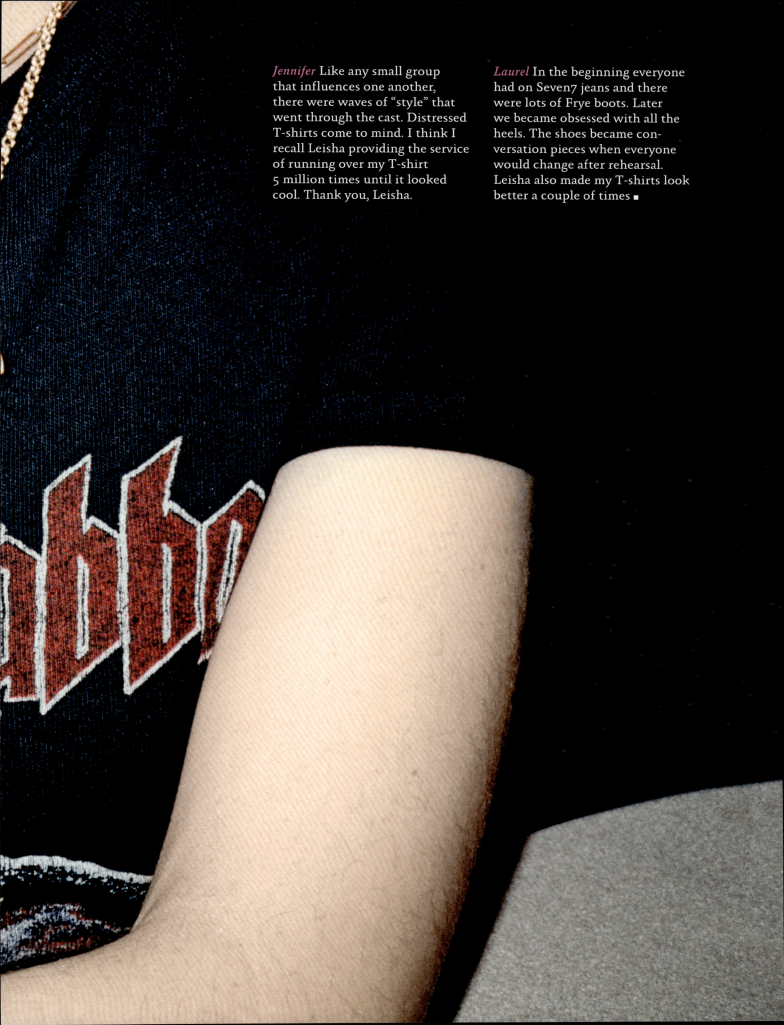

Jennifer Like any small group that influences one another, there were waves of "style" that went through the cast. Distressed T-shirts come to mind. I think I recall Leisha providing the service of running over my T-shirt 5 million times until it looked cool. Thank you, Leisha.

Laurel In the beginning everyone had on Seven7 jeans and there were lots of Frye boots. Later we became obsessed with all the heels. The shoes became conversation pieces when everyone would change after rehearsal. Leisha also made my T-shirts look better a couple of times ■

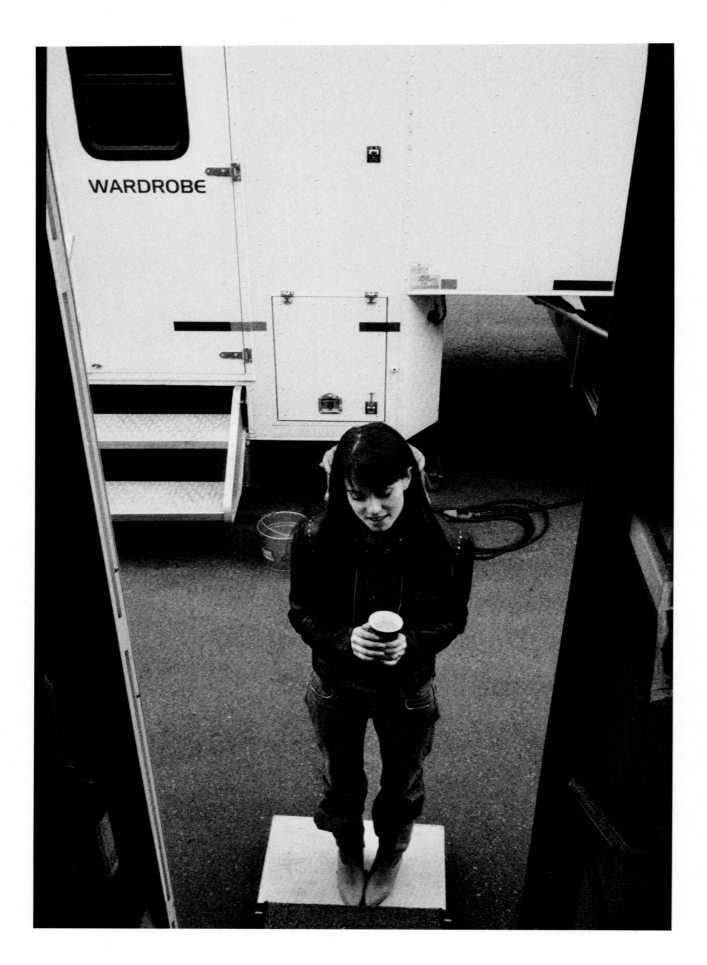

Leisha [Looking at the photo] I can't believe your outfit.

Mia It's a good outfit.

Leisha It is a good one. So edgy.

Jennifer You were always very good about dressing for work, even.

Mia Was I?

Jennifer Yeah, you always had great outfits.

Leisha That's in your character wardrobe?

Jennifer No, that's Mia's—those are Mia's clothes.

Mia Can I see?

Leisha You're wearing cowboy boots. You never wore cowboy boots.

Mia I could be wearing your shoes because we were living together at this point.

Leisha I know, but I don't have cowboy boots. Did I? Maybe I did.

Mia Let's see. Can I see the outfit again?

Jennifer Let's go back.

Mia Sorry.

Leisha Okay, those are your jeans.

Mia It's my outfit.

Jennifer It's definitely yours. Every day you'd come to work with something fantastic. Like, look at you right now. It's crazy, with the little white dress with the lace and the gold shoes.

Leisha [Looking at the photo] I know, but that seems so—not the way you dress. That's what I don't understand.

Jennifer Yeah, but I think there are phases, right? You try out different things.

Leisha There is a little dyke feeling to that outfit. I must have been rubbing off on you, the roommate.

[laughter]

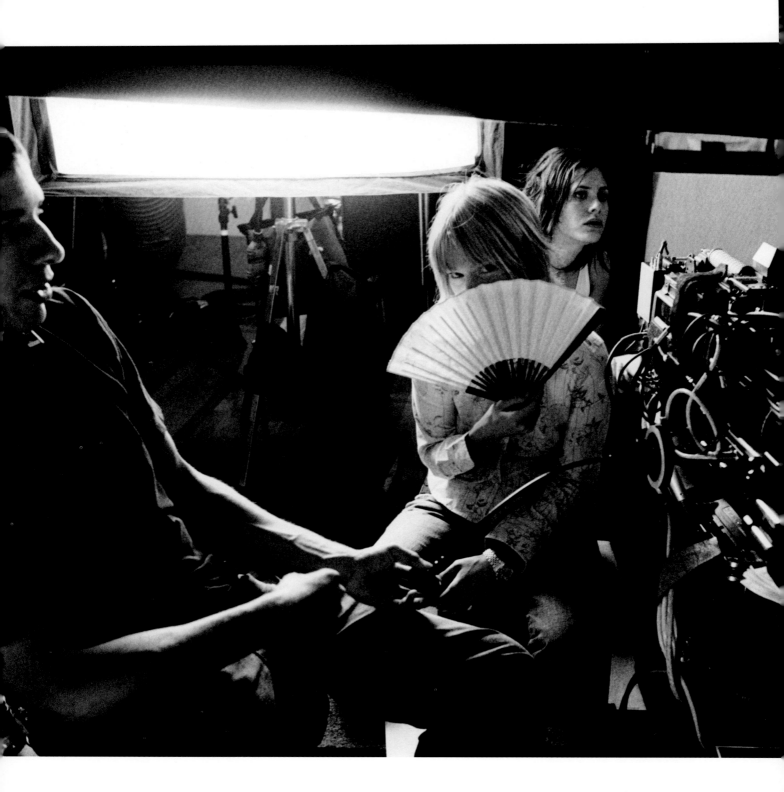

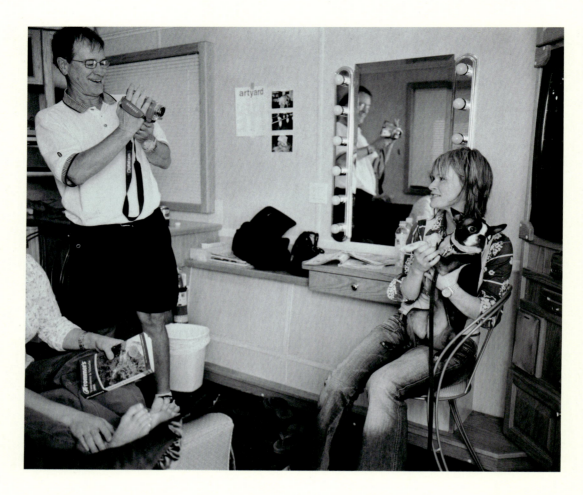

Mia [Looking at photo] Hmm. When did you have that hair?

Leisha I don't know.

Mia First season. But Leisha, you were advising everybody on jeans.

Leisha What?

Mia You became like the go-to person for jeans.

Jennifer No, it's true.

Leisha But look at how I'm dressed. How can that be possible?

Jennifer But we believed you.

Leisha Look at me.

Mia Leisha, you had a whole system for washing jeans.

Jennifer Yes.

Leisha What?

Jennifer And the T-shirts.

Leisha What are all these—

Jennifer I brought my T-shirt that you helped me—

Leisha Distress?

Jennifer Work on. Yeah, you were the fashion consultant.

Leisha That's HI-larious, you guys. I'm sorry you took me seriously. Now you know better.

Mia Look at how cute you are. I love her hair like that ∎

Kate You were really big on your white shirts with the big collars and the big cuffs.

Jennifer Yeah, yeah. It was all about the white shirts—and cuff links.

Kate And the cuff links!

Jennifer I loved my cuff links.

Kate Oh my God, never fail with those cuff links.

Jennifer You know what? Sometimes, I still crave cuff links. ∎

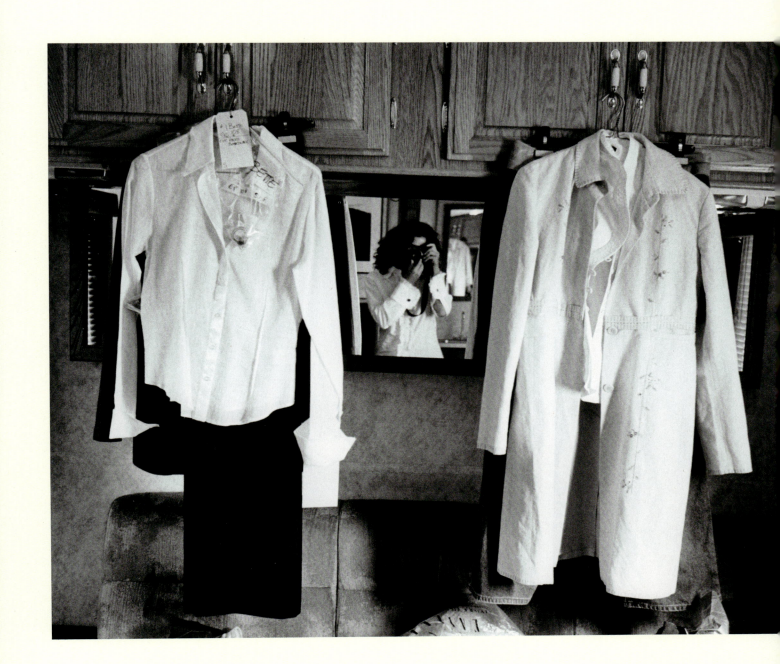

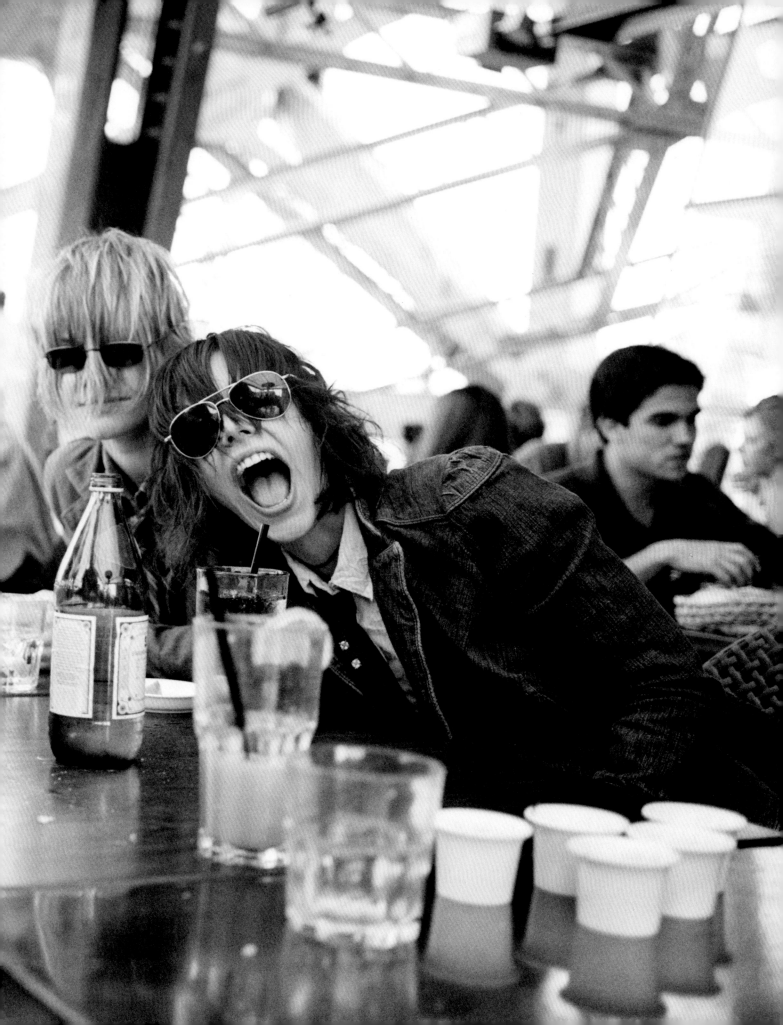

JERRY OFFSAY, PRESIDENT OF SHOWTIME

FIRST POSTER PHOTO SHOOT

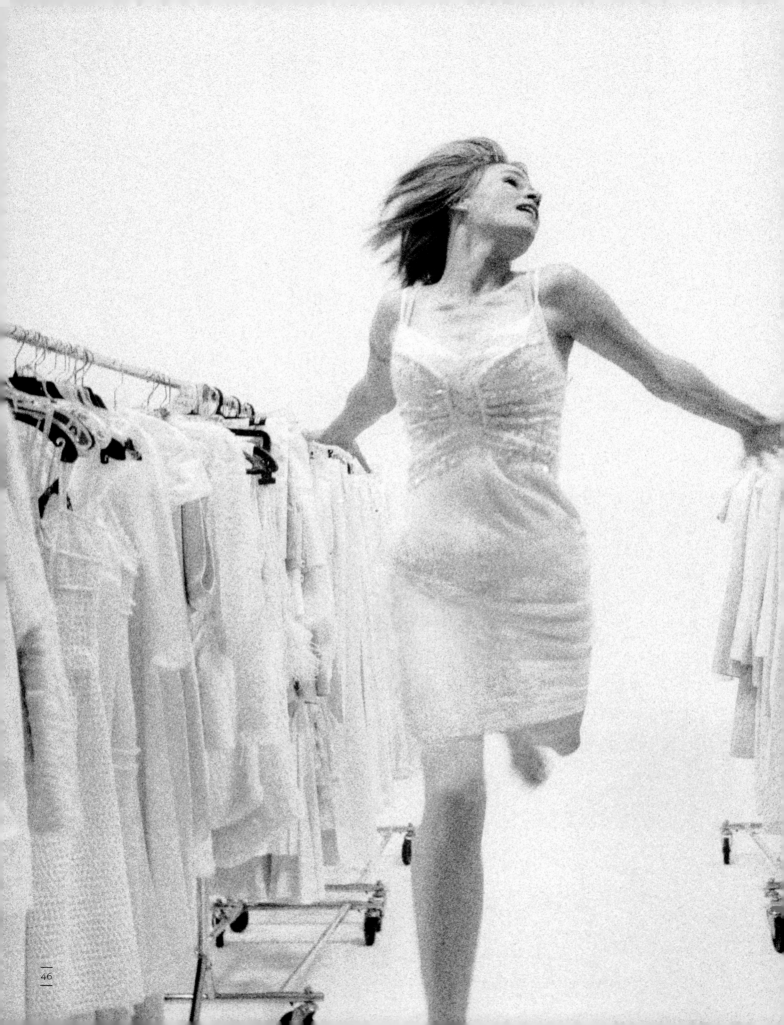

VANITY FAIR *PHOTOSHOOT, DRESSING ROOM*

Mia The *Vanity Fair* photo shoot was fun and so strange. The show had not come out and suddenly we were being photographed. The dressing room was this crazy room with row upon row of gowns. It sort of made you feel like you had arrived in a fairy-tale land ■

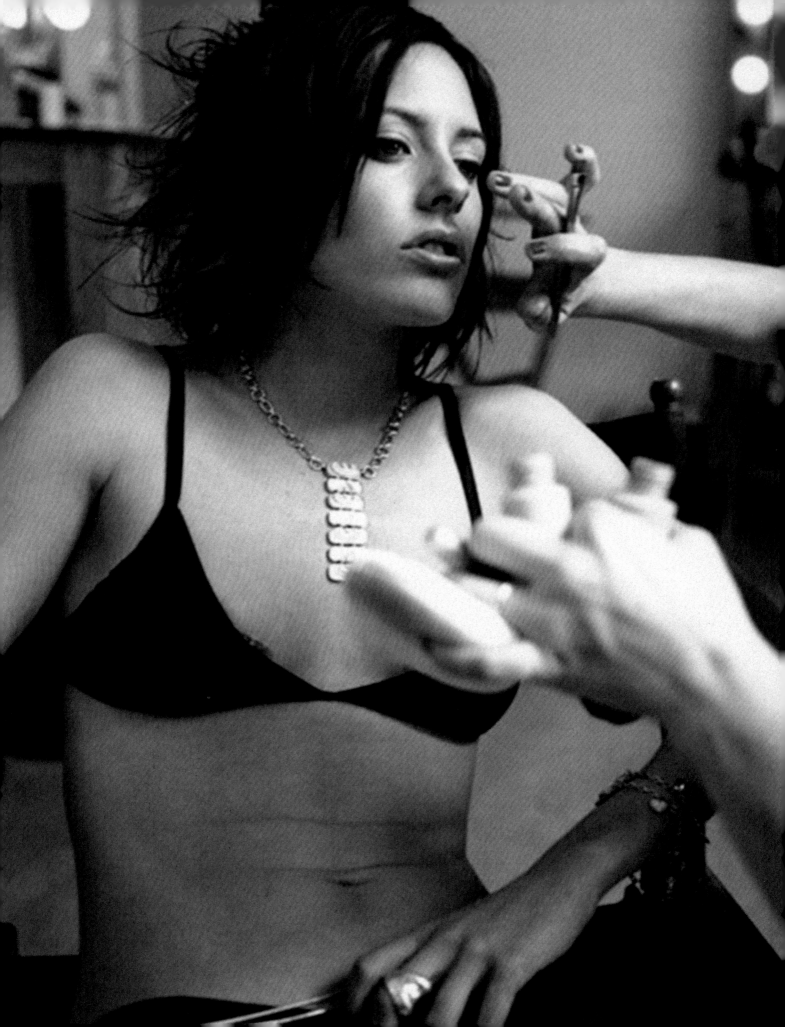

VANITY FAIR *PHOTO SHOOT*

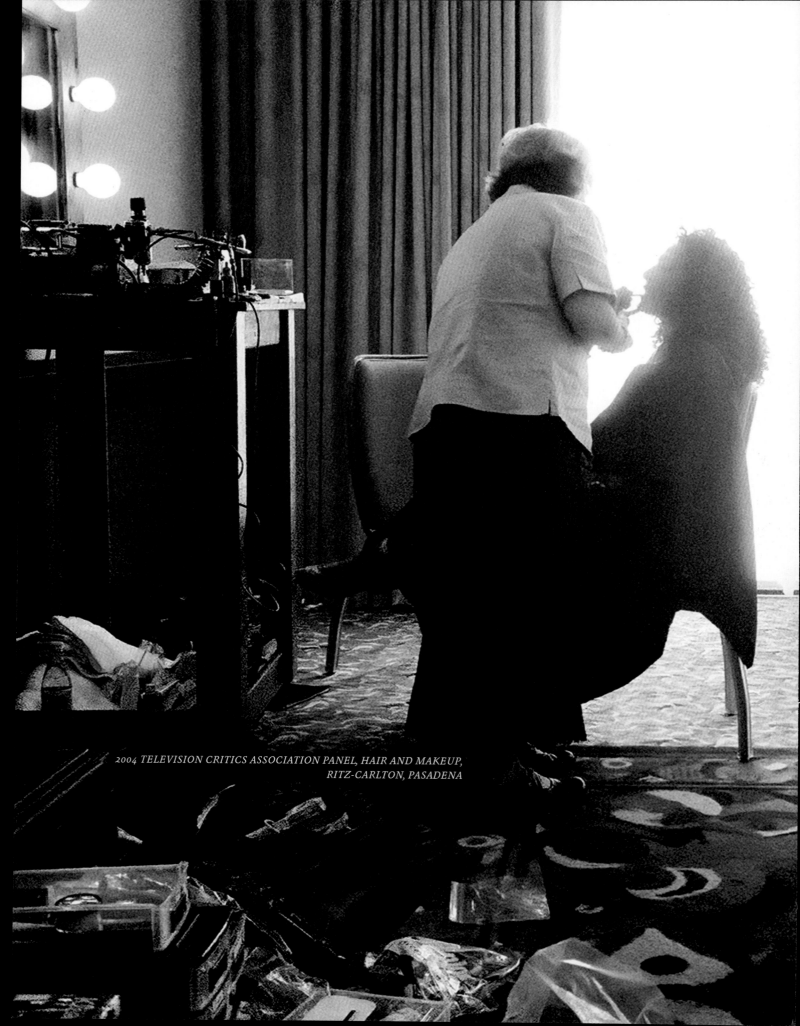

*2004 TELEVISION CRITICS ASSOCIATION PANEL, HAIR AND MAKEUP,
RITZ-CARLTON, PASADENA*

Jennifer Remember when we had to go to the TCAs?

Leisha First season, I wasn't invited.

Mia Yeah, but you sat in the audience. You were supporting.

Jennifer Why do you think they invited everybody and had some people sit in the audience?

Leisha Umm, I don't know, but I remember sitting in the audience with Kate and Erin, and we all felt like the biggest losers.

[laughter]

Leisha But I didn't know anything—like the whole experience of *The L Word* was a learning session for me from beginning to end. So I didn't know that sitting in the audience was not normal. My gut told me something was off about it—that only half the cast was onstage, but I just figured that's how it usually went.

Mia And why were you in the audience?

Leisha I was like, yeah, this must be the way it goes.

Jennifer I look back at that, and I wonder—Why not just have everybody on? It's so clearly an ensemble show, and it's much more . . . even visually interesting to see all the women onstage. That in and of itself is kind of interesting considering there aren't many predominantly female casts, but I guess they didn't know what the show was, really. Nobody knew what it was gonna be so— >>

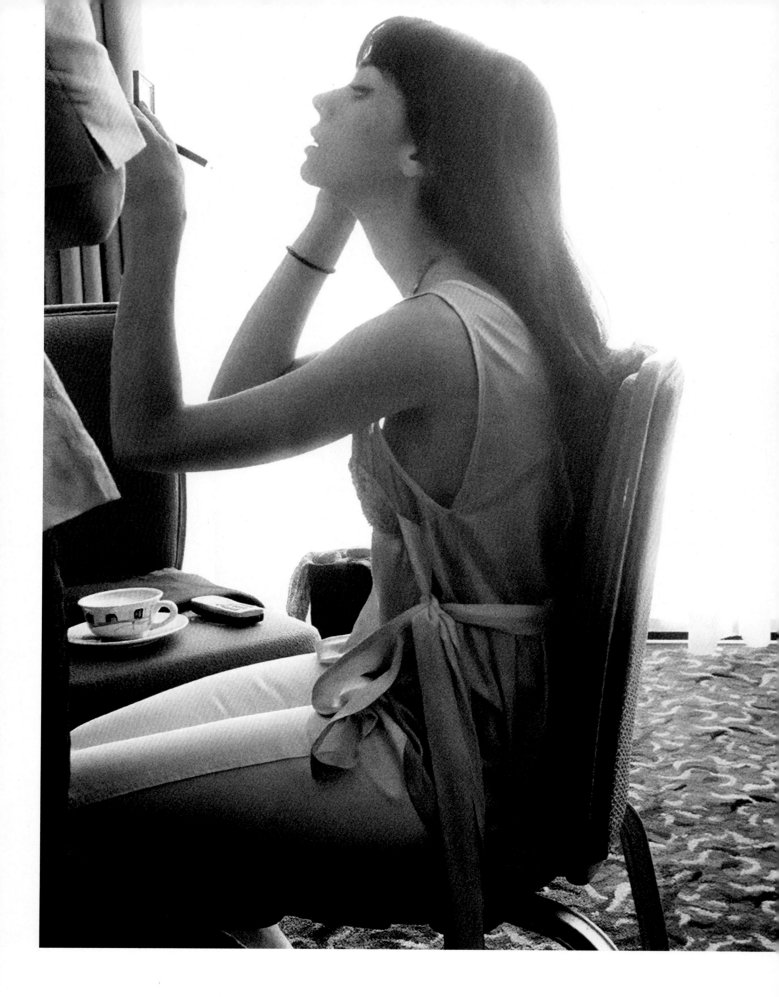

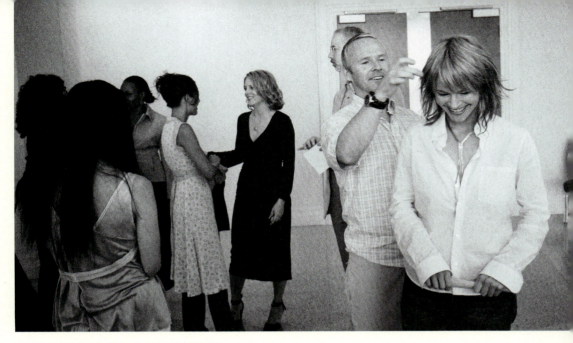

WITH PAUL EDWARDS, KEY HAIRSTYLIST

Mia No.

Jennifer No.

Leisha I don't think so.

Mia I don't think so.

Jennifer But I had fun getting ready for it because it was one of the few times where we all were in the same—for those kind of events—where we're all in the same room getting ready.

Mia You weren't involved in that, though.

Leisha Nope, I wasn't there for that either.

[laughs]

Jennifer They didn't give you hair and makeup?

Mia No.

Leisha No. We just showed up.

Mia They had to go through—stand in line.

Jennifer No, you did not.

Mia Yes, they did.

Jennifer My God am I clueless. I just thought you were in a different room.

Leisha No, we literally stood in the lobby and waited.

Mia They were spectators.

Jennifer Shut up!

Leisha Like proud parents.

Jennifer That is so weird.

[laughter] ■

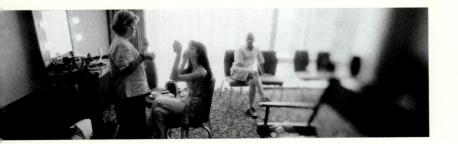

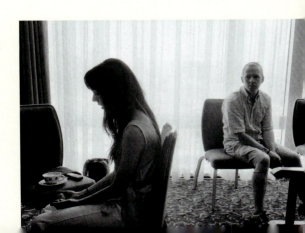

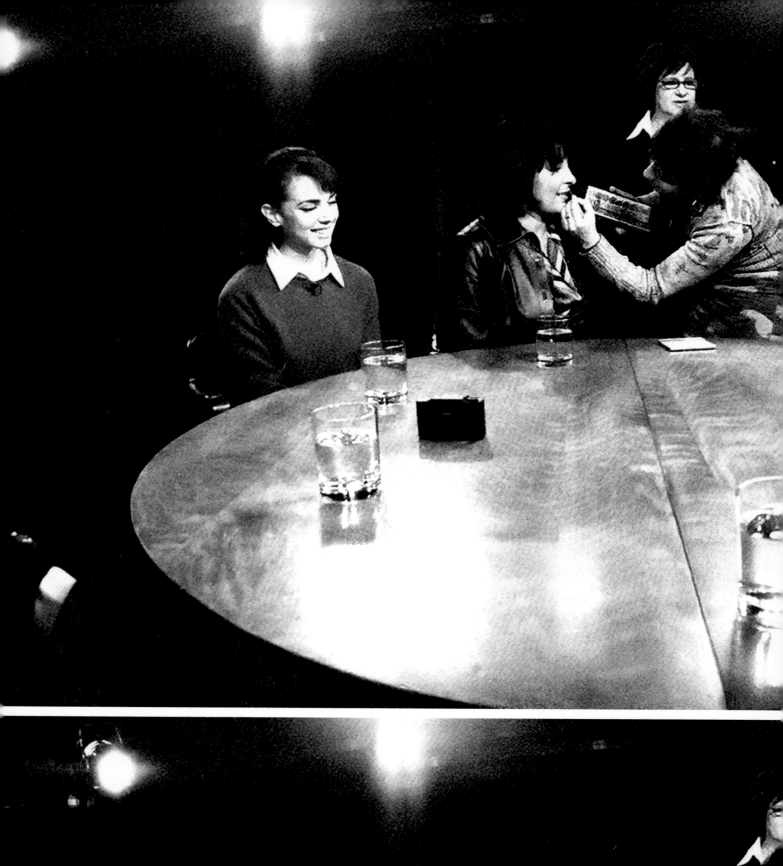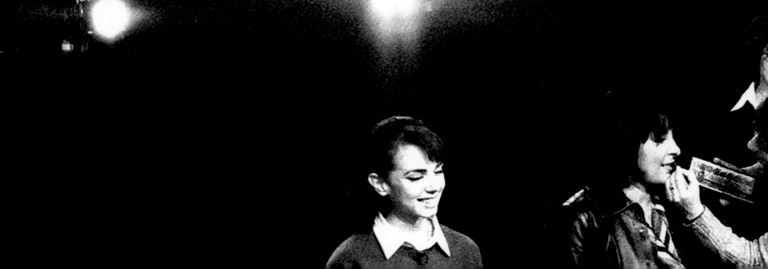

MY SPEECH:
Since I can remember I have always been looking for my tribe, my people, the ones who stood in the world as I stood in the world and who would give me strength just from knowing that I didn't stand alone. There is always a feeling that you are invisible until the world somehow proves it to be otherwise. If you are lucky, you see yourself reflected back to you: in your family, in stories, in movies and television. You are made visible through love and through culture. Growing up as a biracial child on the South Side of Chicago I knew what it was to feel invisible because the only place I saw myself reflected other than in the faces of my family was through Spock on *Star Trek* and our dog. Need I say more?

Now that I am older, I realize I am a member of many tribes. I belong to this tribe. I feel an amazing bond with the women on this stage. There is part of me that is made visible through their love, through their love of their work and for one another, their dedication to the truth. I have the courage to see parts of myself that were invisible to me when I witness their joyful fearlessness.

But you know, sometimes you have to kind of earn your place in a tribe. Everyone else on the cast seemed so confident, so sure of themselves when we started shooting this show, and I felt I was perpetually in a state of unknowing. I remember the first time I even thought about shooting my first sex scene on *The L Word*. The scene comes at the end of the pilot and we shot it near the end

BEHIND THE SCENES:
Women's Night is one of the first events where we are asked to speak as a group. No one is singled out to represent the cast. We are all asked to speak individually about our experience on the show and what it means to us. It is one of the first times that it dawns on us that our experience as a cast might bear some relevance for someone outside our immediate circle. It is one of the first times we sense the larger community of which we are now a part.

We sit together at a large round table, waiting for our turn. We follow the program of speakers. We are all a little nervous. It is a formal, evening event. Full house. One of the more prevalent questions is not "Is there any more red?" It is "Where is Mia?" The time when we will be asked to go onstage is rapidly approaching and Mia is nowhere in sight.

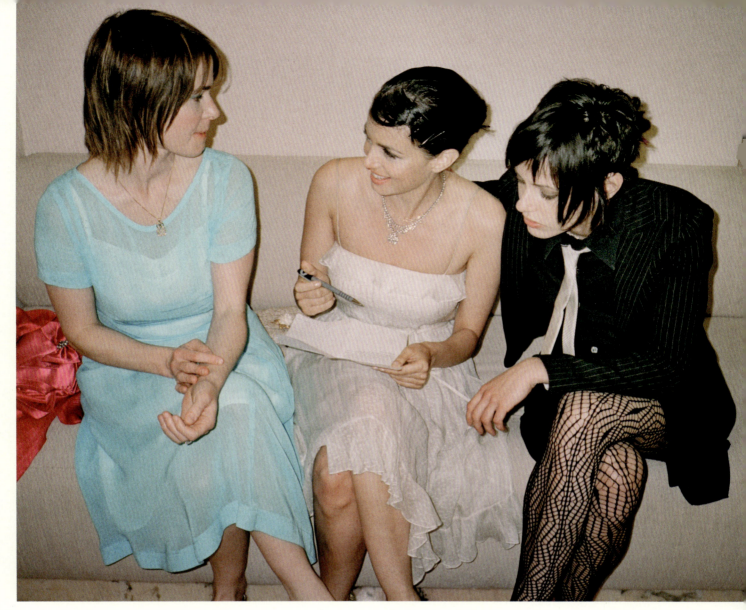

WOMEN'S NIGHT EVENT, BEVERLY HILTON

of our schedule. And really, up until then, I had spent so much time thinking about other aspects of my character. I mean I was thinking about Bette the control freak. Bette the museum director. Bette wanting to start a family, dealing with issues of race. Then it hit me—oh right, oh my God, she's a lesbian, and I have a sex scene to do and I haven't a friggin' clue as to what I'm supposed to be doing.

I was totally panicked. And I thought to myself, "Okay, what am I suppose to be DOING? Is there some secret way of DOING things, you know INTIMATE things, that only lesbians know about? Is there an esoteric code?

Mia arrives fifteen minutes before we're supposed to go onstage. Her flight from Tulum was late. She is tan and gorgeous, looking like some French movie star back from her holiday.

Is it maybe on the Internet? www.gayladysecretcode.com? And I think, "Oh my God, I'm just going to look like a big fat clueless hetero and the entire gay community will laugh at me and

She doesn't have a speech.

>>

realize what a bourgeois chump I am." And then I realize something . . . I figure out the code. The scene, this sex scene I have been obsessing over is not about sex.

This scene is about two women in a seven-year relationship who've had a difficult time and now they're reconnecting. This scene is about love. It is about love. That's the code.

She thinks it's hilarious. The director of the event provides her with a speech in warp-minus-ten speed. Mia looks at it quickly, makes a face. We retire to the bathroom, Kate, Leisha, and I, to do a rapid rewrite.

And now I hope through *The L Word* to become an honorary member of the gay tribe. I cherish the thought that some young girl or woman somewhere may one night turn on the television and for the first time ever see her life represented—not as an isolated incident but as a multiplicity. Her overwhelming fear may have been that she might never find her tribe, she might never find love, and now she knows that they are both out there waiting for her.

The group rewrite is largely ineffectual, but incredibly entertaining. Mia finds time to moisturize her legs.

Love is large, love defies limits. Love is by definition sacred. Not some love between some people, but all love between all people. How can anyone say one person's love is more sacred than another person's? If indeed it is love, it is sanctified. If it is indeed love, the right to marriage is not questionable. In my mind, nothing pleases God more than love. I do not think it pleases God to codify bigotry. I do not think it pleases God that fear guides the hand of the law in the name of a cultural war.

For me, this show, *The L Word*, is about love. The most radical thing about it, the most galvanizing thing about it, the most inspiring thing about it, the most unifying thing about it, is that it's about love. And in the face of love, especially the expansive love generated through our own tribes, through our own communities, fear is a petty emotion.

On behalf of the women with whom I stand here tonight I would like to say we are proud to be a part of Ilene Chaiken's vision. We're grateful to Ilene for creating this historic series and to Showtime for giving it a home. Ilene listens openly to our ideas and so often generously finds ways to incorporate them into her stories. Her door is always open. Such a sense of egoless collaboration

« and mutual respect is all too rare in this industry. Ilene creates a safe place for us as actors, as artists, to push ourselves into unfamiliar and sometimes scary territory so that hopefully we can be truthful in our storytelling. Ilene's unflinching fearlessness guides us to the beauty of the truth. And certainly the world desperately needs a dose of both truth and beauty right now.

We walk onstage. We give our speeches. Mia is charming. She swears often and with gusto.

Ladies and gentlemen, please join me in presenting this year's Community Role Model Award to Ilene Chaiken ∎

Later that night, after the revelry, we're sitting at our table. Laurel asks me to go to the bathroom with her (I know, the bathroom again). She tells me she's pregnant.

I try to suppress my elated scream. I am so happy for her. We walk out of the bathroom as if the world hasn't been unalterably, numinously changed ∎

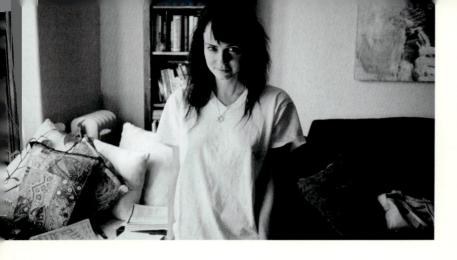

MIA AND I GO TO THE GOLDEN GLOBES AS GUESTS OF SHOWTIME, BEVERLY HILTON.

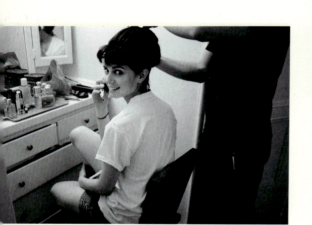

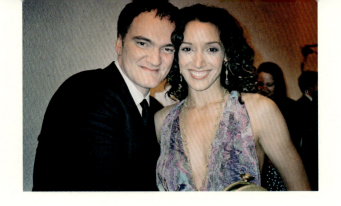

Jennifer,

I feel blessed to have you as a co-worker and partner. You are one of the most generous actors I've ever worked with. When I think about "courage" I think about you. I look forward watching our families grow because I know they will, and I'm so glad to have shared this journey with you.

Love,

Laurel

P.S.
check out the other girls necklaces too!

season 2

> CARM
> You want to play?

> SHAN
> Looks like I'm gc

> CARM
> The game is calle

> CARM
> Here's how we pla
> stop kissing. We
> touch me you lose
> whatever I want w
> anything. You can

> SHAN
> What if you touch

> CARM
> I lose and I'm yo
> you want, whateve

Shane smiles. Carmen kisses

> CARM
> Don't get too hot
> to be my slave.

(CONT'D)

g to.

"Too Hot".

 (CONT'D)
 We kiss. And we can't
n't touch. If you
nd that means I can do
h you. You can't say
 stop me.

e?

re slave...whatever
 Ready?

er.

 (CONT'D)
hane. You don't want

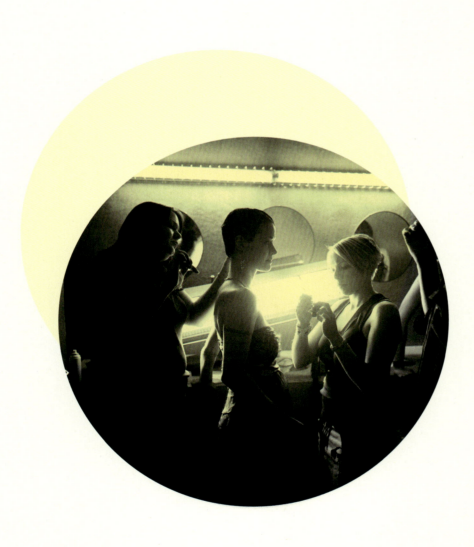

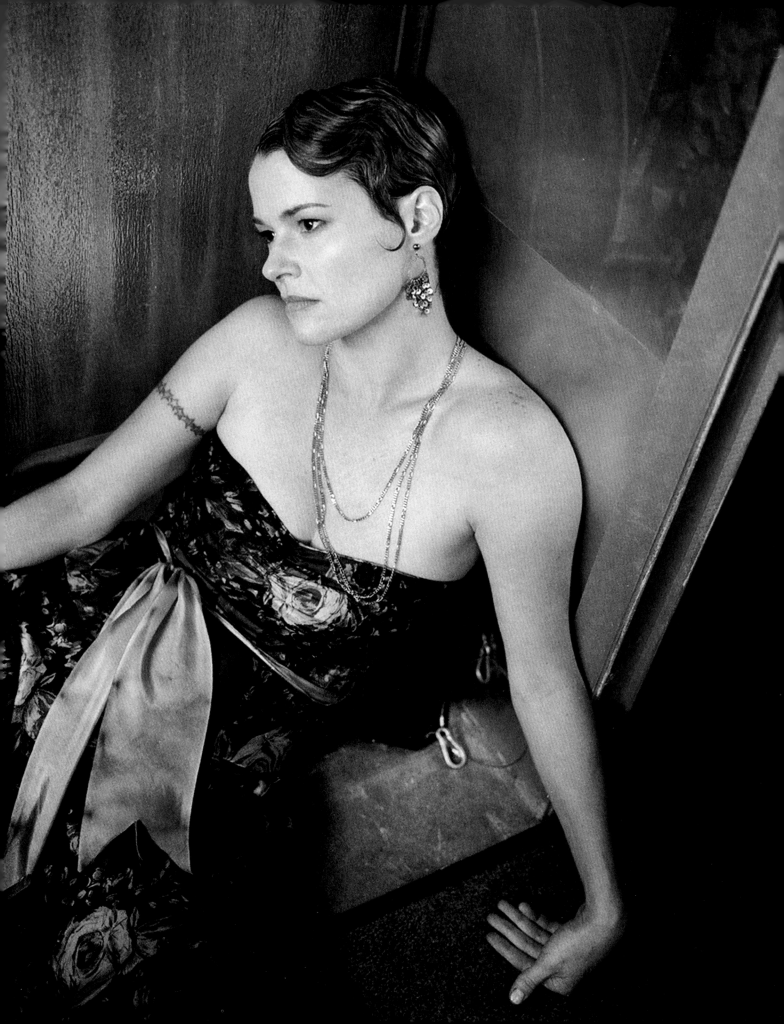

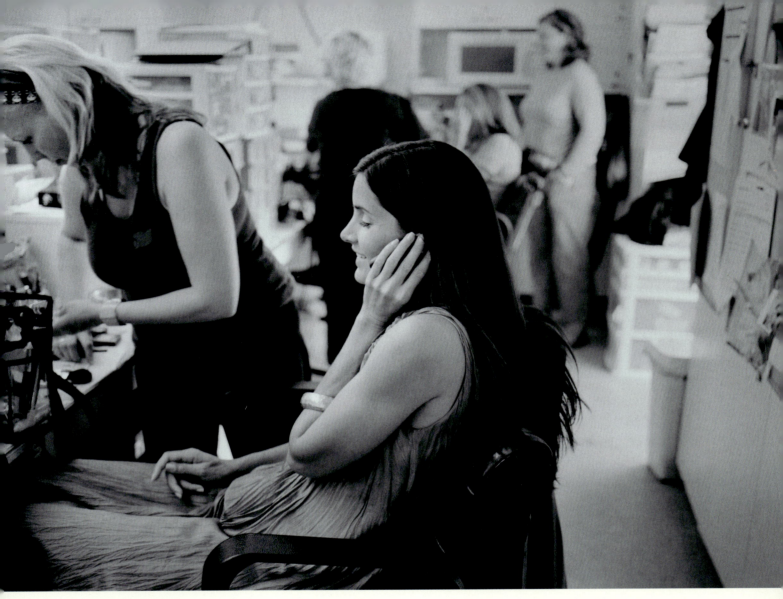

RACHEL SHELLEY

Rachel Shelley Joining the cast of *The L Word* is a bit of a blur. One moment I was in London contemplating how to spend my summer, the next I was on a plane to Vancouver having signed away five years of my professional life. It really was that fast. And I forgot to pack any underwear.

But that was the least of my worries. My first day of filming was seventeen hours long. I was tottering around on ridiculously high heels, desperately trying to remember lines I'd read for the first time on the plane the day before. I was speeding on caffeine to combat not only jet lag but the preceding night of inevitable insomnia and a 4 a.m. wake-up call. Helena Peabody was supposed to cut "an arresting, commanding presence" when she walked into Tina Kennard's charity office, her film crew in tow. And remember, they'd been trying to cast this character for months; they were a whole episode behind schedule. The pressure was on. They wanted an ice maiden, someone

"supremely enfranchised," the script said, powerful, intimidated by nothing and no one. So why was I trembling inside? Why was my heart pounding? On the first take I screwed up my line and tripped over some cable on the floor. I laughed, maybe a little overzealously, and some of the crew, including Laurel, thankfully laughed with me. I'm sure somewhere a producer was wincing, but it was the slap I needed to ping me back into the present. This was my new job. I had better step up. I was Helena Peabody. I put my glare on full beam and tried again. No one was going to mess with Helena Peabody, especially not little ol' me.

I always thought it was pretty exciting when someone new came along. And rightly or wrongly I always felt a little sorry for them, having once been in that position myself. One way or another they were bound to change the dynamic in some way ∎

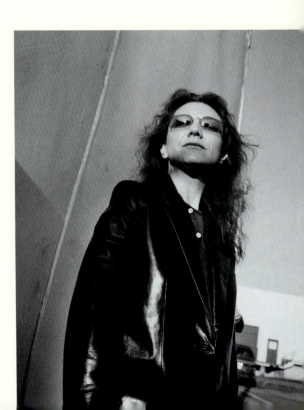

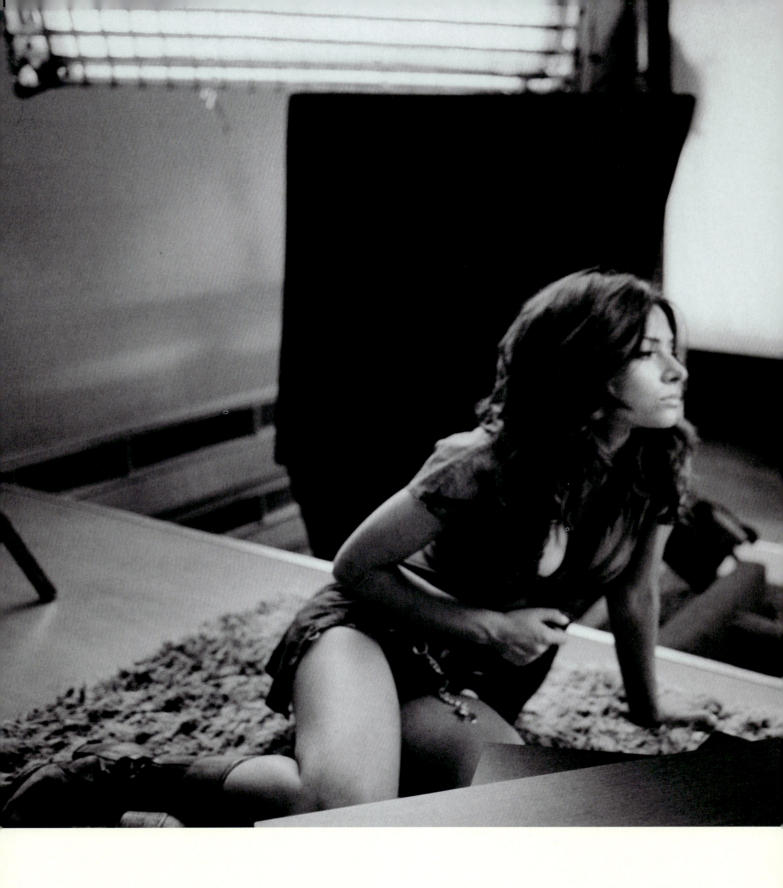

SARAH SHAHI

Sarah Shahi I remember seeing the billboards from the first season and I thought, "Wow, there's like 1,900 women on that show; how come I didn't go up for that show? That's ridiculous." And then I got the audition for Carmen. But during that period, I was going through a really hard time in my life, personally. And I was incredibly vulnerable and just in this really weird space in terms of life and my priorities and what I wanted and where I was going, and I started thinking, what am I ready for? I remember walking into the audition and I didn't really care. I thought, "This is just another audition and it doesn't matter if I get this or not—I am living life, I'm experiencing things. It was just . . . you know how they say when you really *want* something it doesn't happen, but then when you're like, "Whatever happens, happens," that's when things come to fruition? I feel like it was one of those.

Jennifer Where you let go.

Sarah I had so many other bigger things going on in my head at the time that this was at the very bottom in terms of priorities, because of all that stuff that was happening . . . So I walked in and I remember playing everything super-light. I just wanted everything to be light in my life, because I was in such a weird place, such a heavy place, that I was like, "I just want to smile. I just want to laugh." I think that's

how I played it. So then it was like they want to give it to you. It was like, Huh, what? What?! And I remember telling my mom about it, and my mom was like, "Great, that's awesome! What are you going to be playing?" And I'm like, "I'm going to be playing a lesbian." She went, "What?" I'm like, "Mom, it's fine. Don't worry, everything's great." Cut to my mom later, who thought it was the coolest thing in the world. She would watch every episode. "Carmen and Shane rock!" But it definitely took her some time to get her head around it.

Sarah And then I'm thrilled. I'm moving to Vancouver. I'm feeling like an adult for the first time in my life. I was twenty-three and really had no idea what I was doing. And I remember it was the first day, and in the scene, Shane is supposed to go down on me. And I remember going, "Oh my God. Like this is a big deal for me with guys, how am I going to do this with a girl?!" And then I thought, I hope I don't smell down there. Then I remember going, "Okay, I think I'm good. I scrubbed a lot the night before." And then I got on set and it was the first time I met Kate [the first time I read, I read with the casting director]. It was like, "Sarah, Kate. Kate, Sarah. Kate, you'll be going down on Sarah in the scene." [laughter.]

Jennifer Who was the director?

Sarah I believe it was Dan Minahan. And then I just remember the whole time I kept thinking, "I hope I don't smell funky down there. I hope I don't smell funky down there." That was the only thing that was running through my mind. And then there were the lights and I started to sweat and I got

really nervous. And I remember I kept saying, "I have to go to the bathroom," because I wanted to make sure I was clean. And anyway, it was like, "Wow, welcome to *The L Word*." Wow, that was definitely one way to break the ice.

I loved working with Kate. I felt like she and I really got along because we were both like two nonbullshit people. And I also remember when I came into the group, they already have something established with one another. I'm not going to try to be anybody's best friend. Like there's a whole family here that's already been established and I'm like a stepchild right now. So I'm not going to push my boundaries and let things kind of evolve organically. And it did.

Jennifer When people would first come on the show you don't know what they're really like. People truly reveal themselves when the chips are down. When you're in a sixteen-hour workday, then somebody's personality really comes to the forefront and you get a sense of who they are. But sometimes you just want to step back and just do your work. You don't all have to be best friends to do your work. But the thing about the show is that people really did form some very important friendships, and I think as a group we were more like a dysfunctional family than we were always like best friends. But having said that, for me, working with women was a very important education. Had you worked with a lot of women before?

Sarah No. After that show was done, I needed to work with MEN. Get me on the set where there's a lot of testosterone because WOW that's a lot of

estrogen! For me, it was more that I realized it's important to have a balance. I'm all for women. I feel like there's so much competition in this business, and I feel like, instead of all this being ruthless with each other, we should root for one another. And it can only benefit me if you succeed. It can only benefit me if another female is the next Steven Spielberg. And I feel like there's room for everybody. But at the same time I was like, wow, it's important to have that balance. The other show I was on, it felt like a boys' locker room, and I was like, "Oh my God, I need some women." But the thing I'm doing now I seem to be really appreciated. Even though there's guys around me all day, it's like they want my input, they care about what I have to say, and it's just a totally different thing.

That was another thing about *The L Word*. Before that I didn't realize it was so nice to be a cast of eight, because the most I worked was four or five days an episode. And that has never happened to me again. And the other thing that was so great, we could change the lines all the time and Ilene was so cool about that, and when I tried to do that on other shows, it was like, N-O. It was not *The L Word*. So with that said, as crazy as it can be working with a cast of nine women there were some pretty awesome components to it, too.

Jennifer What was your favorite moment or season on the show?

Sarah I had a few favorite moments. I really liked the way Shane left Carmen, that whole scene the way it played out. I really liked the way that played out.

Jennifer At the wedding?

Sarah Yeah. The wedding. I really liked how that turned out. There were so many fun moments. The Planet stuff, even though it took FOREVER [to shoot], was just super-fun because it was just like hanging out with your girlfriends like all day long. It was all so free, conversational, and natural that I really liked it.

Jennifer Did you learn anything from your character? For me, playing Bette, I learned how much stronger I was. I learned when someone on a set is trying to make me just the "girl"; there's no way. It became very easy to speak up for myself.

Sarah That experience for me didn't come for me until later, because when I was on *The L Word*, I was so appreciative just to have a job, you know, because it was like before that my dinners were like cans of tuna from the 76 [service station] across the street. Seriously. So I was so appreciative just to be making those checks every week, and it was such a huge lifestyle change for me that I feel like, going back, I would take it and try to be more artistic with it, I would try to create more of a character if I had a chance to go back and do it again. And because I only did her for two seasons, I felt like I didn't really create a character. I felt like I pretty much did me. The thing that I felt like it did teach me, and having such a great acting partner like Kate, is everything was so organic. Everything was really organic. And that was in a way my acting school. And that was a great experience. And I have taken that onto other projects. Everything, with all the girls, everything seemed so organic and natural, the dialogue, and that was cool. To be on something that was loose and you were free to play with it.

What I learned there I have taken with me elsewhere. To be able to at least sound organic and deliver. But I was so young and so naive that I was just happy to make the check. I had no idea what an objective or an intention meant back then. I was like, oh great, if it sounds natural. Whereas now, it's a whole different thing for me. So it was a wonderful acting school. The basics, here you go ∎

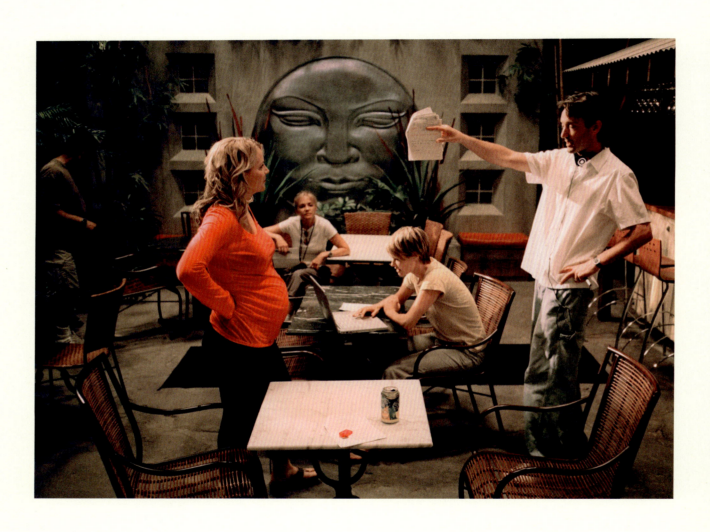

Jennifer We had so many great directors on the show.

Leisha [Looking at the photo] Burr Steers!

Mia You loved him. That was your husband.

Jennifer I know. You loved him and he loved you.

Leisha I don't know what happened with him, but I just was so taken by him.

Jennifer He was really special, I thought. Really interesting. Always asked great questions.

Leisha And his weird voice.

Mia What was his voice?

Leisha He had the weirdest little accent.

Jennifer It was very New England. It was a very New England voice.

Leisha I can't even do it.

Jennifer He was so smart.

Mia But did you love him?

Leisha Loved him. He made me giggle. Like, I felt nervous around him.

Mia Leish, you kind of are blushing!

Leisha I had funny feelings inside.

Mia Did you?

Jennifer He wouldn't pay any attention to me. I remember standing by him by the monitor, you know, trying to get a little attention, and there would be some image of Leisha on the monitor and he would be like, "Doesn't she have a beautiful smile?" And I'd have to say, "Yeah. Yeah, she does." ∎

Rachel That crew is so hardworking it's insane. Monday to Friday they can barely see their families. Up too early and home too late and they never complain. They don't have a place of refuge as we do with our trailers. They just slog away at it all day. I loved Debbie and Joshanna, the onset costume crew. They were so supportive and helpful, great for a gossip and a laugh. I loved the camera department too. As an actor, you spend more time with them than the rest of the crew, standing beside them to do off-camera lines. I liked their slightly warped sense of humor. Their quiet cynicism. A very male energy, but a nice contrast to the rest of the cast and crew. And the droll transpo [transportation] team were a good antidote to a crazy day ∎

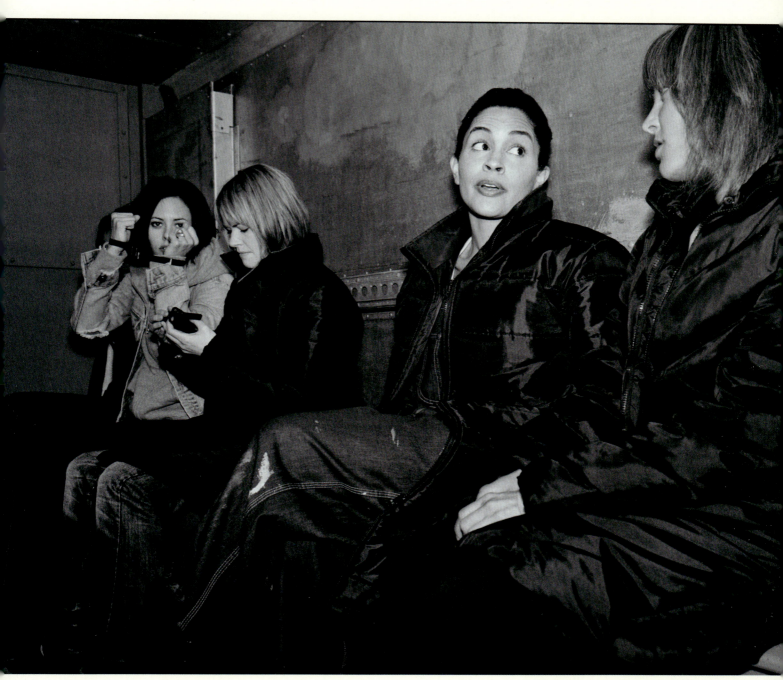

IN THE PADDY WAGON. ION OVERMAN.

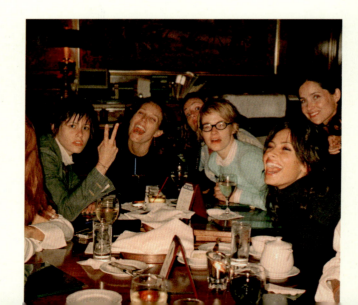

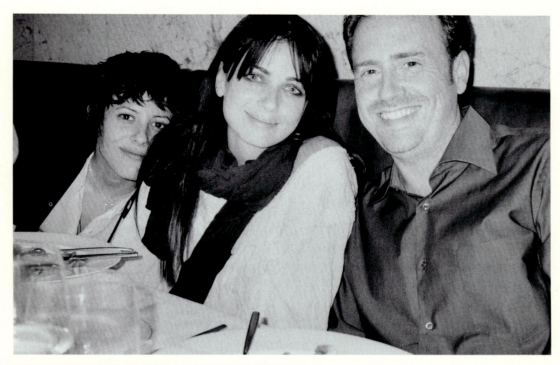

WITH ROBERT GREENBLATT, PRESIDENT OF SHOWTIME

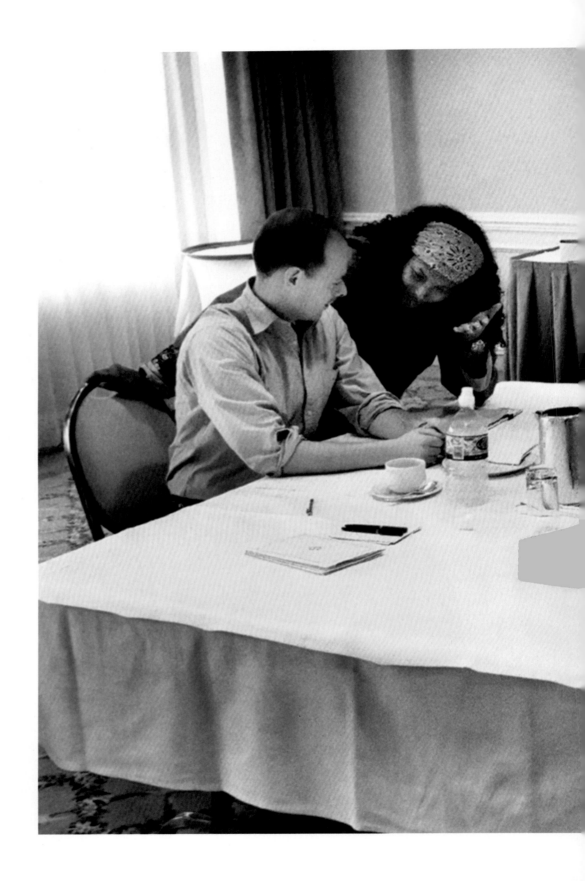

*DAN MINAHAN, OSSIE DAVIS, AND PAM,
REHEARSAL, SUTTON PLACE HOTEL*

IN NEW YORK, DOING PRESS

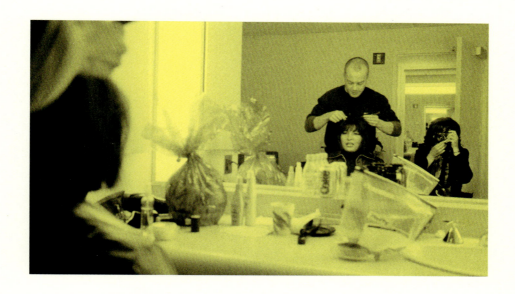

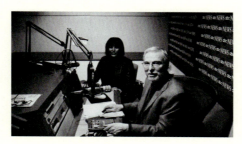

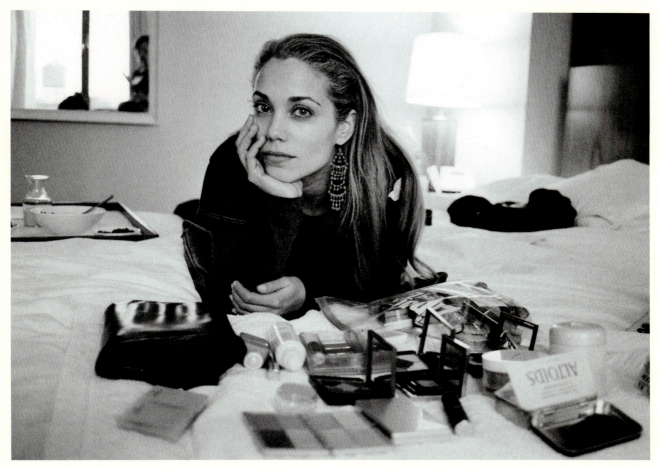

ELIZABETH BERKLEY, VISITING ME IN THE THOMPSON STREET HOTEL

SECOND SEASON PREMIERE, SAN FRANCISCO

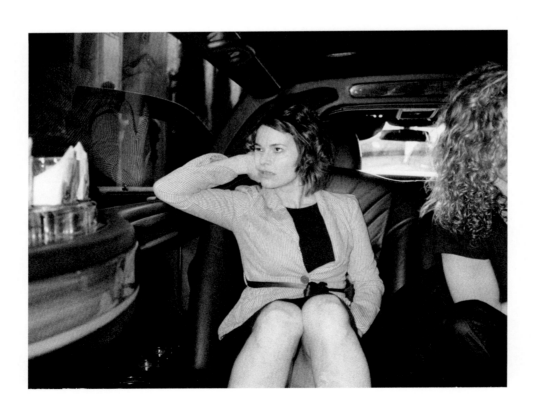

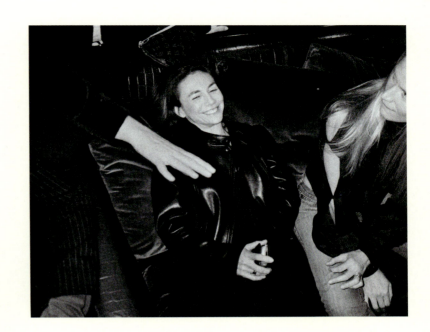

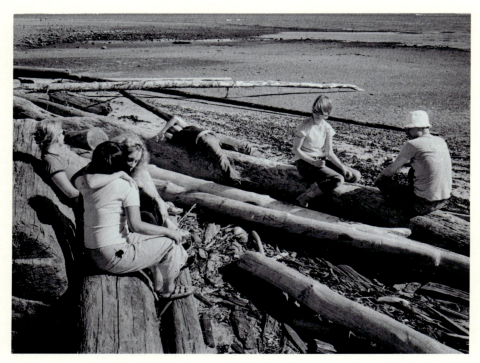

AT ILENE'S HOUSE, WEST VANCOUVER

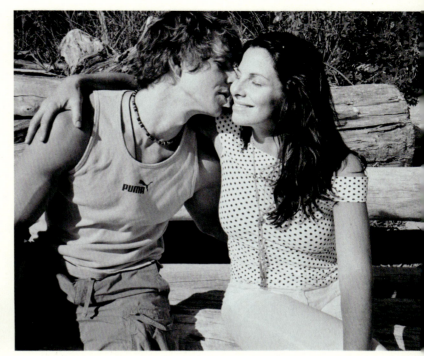

ERIC AND IVY MABIUS

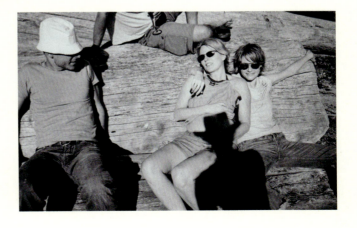

MIA WORKING ON HER BOOK, I LIVE HERE

LEISHA IN MY TRAILER

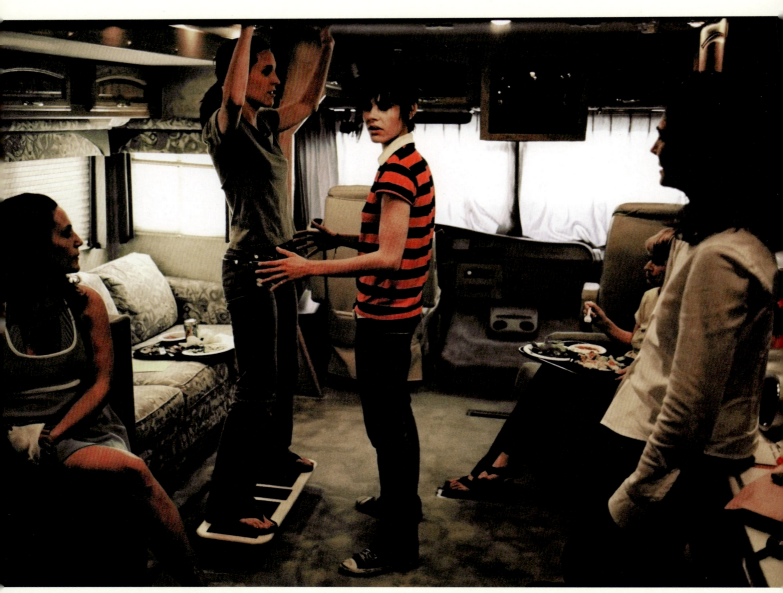

GROUP LUNCH IN MY TRAILER

Erin The working experience was a lot of fun, of course, but the experience I had with all of the women on the show was, to be perfectly honest, far more special to me than the actual work. I think the work we were doing was very important and a lot of fun, and it was interesting and stimulating and all of that, but at the same time, being in Vancouver in this bubble with all these women, which is so rare that you spend that much time with just women, was really empowering, and it was those relationships that were and are so precious to me, and that whole experience was very special. It was Camp L Word.

I felt we should all cry around the bonfire at the end of every season. [laughs] ∎

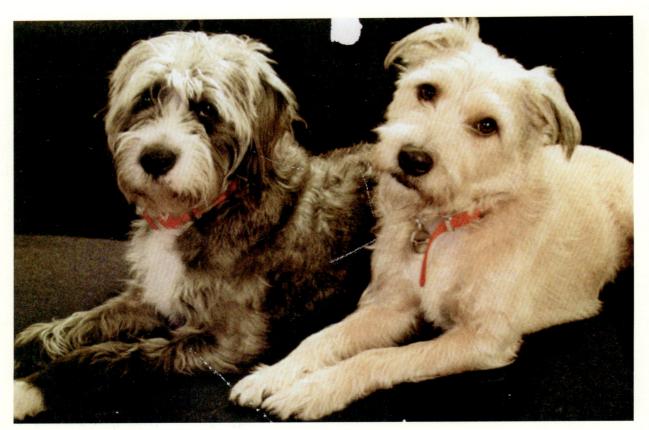

HIRO AND BANDIT

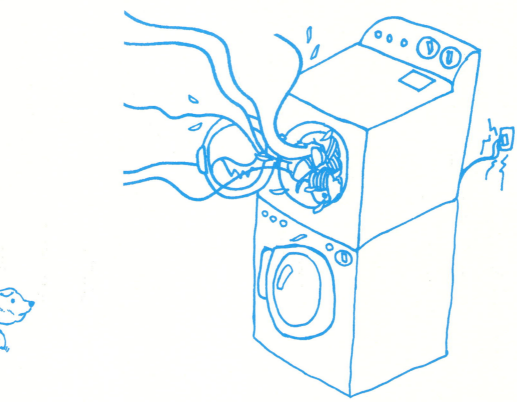

THE DRYER FIRE STORY

Leisha Well, when we [Leisha and Mia] first moved in together the landlady walked me around and I asked, "Where do you clean the lint out of the dryer?" She said, "It goes through the hose—some ventilation system, you don't have to clean it." And I thought, "Oh, I don't have to worry about it." Well, apparently that wasn't the case and the lint—

Mia . . . caught on fire.

Leisha caught on fire one night . . . We were sleeping . . .

Mia . . . fast asleep . . .

Leisha —and, at three in the morning, my dog Bandit woke me up and I looked at the doorframe of my bedroom and it was lit orange. And I screamed and I screamed for Mia and I . . .

Mia . . . and I didn't hear you scream . . . I was fast asleep.

Leisha Right, and I opened the door and there's a fireball on the ceiling.

Mia And what did you say?

Leisha It was the scariest thing I've ever witnessed.

Mia "Mia there's a dryer fire! Oh my God, there's a dryer fire!"

Leisha And I was blind—we were both blind.

Mia I remember looking for my glasses.

Leisha —and I couldn't find my glasses either and all I saw was this giant flame.

Mia And then you grabbed Bandit.

And you were like, "JUST GO!" And I was like . . . I thought I could fix it . . .

Mia You were running up and down the stairs.

Leisha Yeah, up and down . . .

Mia —with Bandit, and I was, in the meantime . . . were you dressed at this point?

Leisha I probably had something on.

Mia And, um, I got my passport [laughter]. I was like, "I'm not leaving here without my passport and credit card!" And then we went downstairs and the fire trucks came and it was all very, very dramatic and Erin wasn't there, so we slept at her house that night because she lived next door to us. And then we moved into the Sutton Place Hotel for two weeks.

Jennifer —while they fixed everything . . . But then you moved back in, right?

Leisha Yeah.

Mia We were fine. But I believe that the reason this dryer fire started was because we had been to Little India and bought [Leisha laughs] a little Ganesh [figurine].

Leisha Ganesh.

Mia . . . and we had decorated our house . . .

Leisha . . . with lots of Indian gods.

Mia . . . and yes, and unfortunately we weren't that respectful to the Ganesh. You know, we would have the cell phone and we were like, "Oh, it's for you" and we'd pass it over to the Ganesh. What else would we do with it?

Leisha I don't know, but we weren't really great with it. So we think that the gods were punishing us [laughter].

Jennifer The good news was that after hearing that story, you inspired several people to compulsively clean the lint out of their dryers.

Leisha Joann, the key makeup woman, says she thinks of me every time she cleans her lint out. It's like I'm saving a fire from happening one day at a time ∎

ME IN MY TRAILER

Jennifer For me, second season was excruciating in the best kind of way. Nothing good happened to Bette. Everything was a struggle, romantically and professionally. As an actor it was a delight, but still I remember bursting into tears of joy, and running around the circus after I read script number . . . I believe it's 208, where Bette has a brief victory at work, proclaiming, "Something good happens to Bette! Something good happens to Bette!" It was a delicious reprieve.

Season two, everyone else in the cast was feeling uncomfortable. Leisha said, "It felt like something was threatening what we had all created that first season. We were all filled with so much hope and something pierced the bubble. And I'm not sure exactly what is was but we were like a mother lion protecting her cubs. We all became very protective of something we loved so much." The ground seemed to be moving under our feet,

and later we came to find there were seismic shifts happening in the front office. But at the time we couldn't quite place what was going on, so in an attempt to change things, "to make it positive instead of fighting," we boldly went where no cast had gone before: we painted the craft service room. In an attempt to alter our environment we painted the previously militaristic room in a pastel rainbow. It looked like a nursery, which in retrospect, with six cast members later giving birth, proved prescient. Mia made a little wishing tree, where cast and crew offered up their aspirations and jokes.

We were still hopeful. The season was painful, but not without purpose ∎

KELLY LYNCH AS IVAN

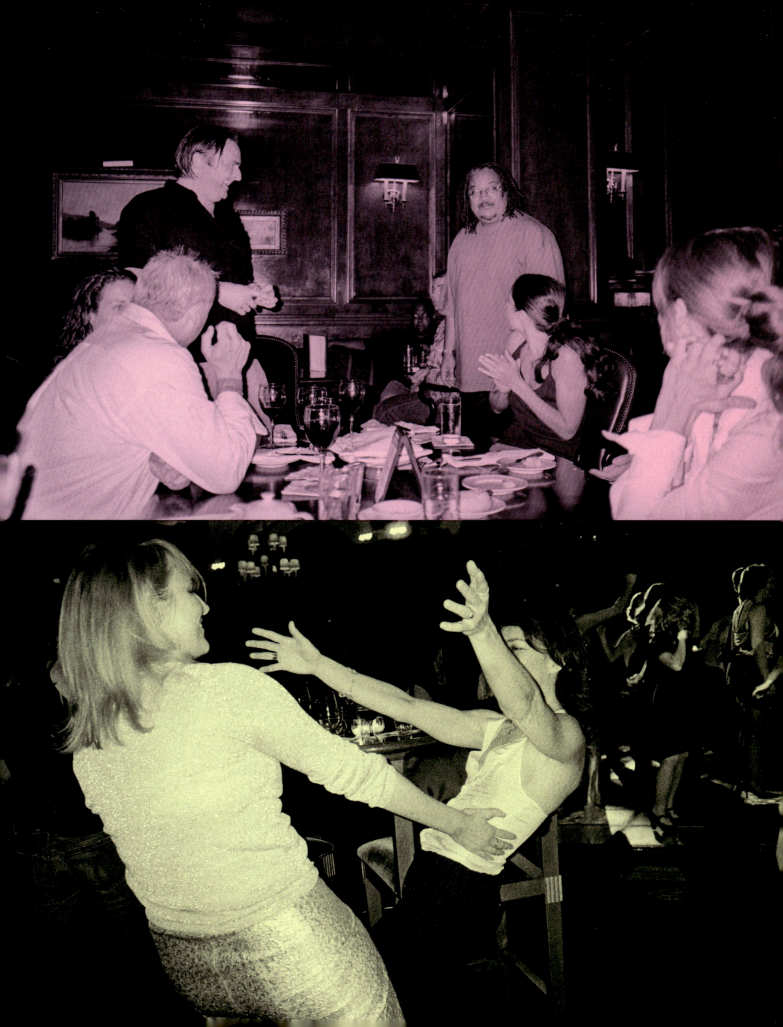

Leisha [Looking at photos] Seeing Erin in the pictures makes it all make sense.

Mia What do you mean?

Leisha It just feels like the show.

Mia Right.

Jennifer It changed so much when she left.

Leisha Oh my God, it was a totally different experience.

Jennifer I can't really put my finger on it, but it became more of like a franchise to me, not that I didn't love some of the things that I got to do, but it became more of a franchise, and less of a family.

Leisha Yep ■

KATE, LEISHA, AND FLOYD

Kate [on getting Floyd] Leisha and Erin came with me to the pound. Floyd was the first dog to be found. He was caged next to this Chihuahua puppy that everyone was freaking out over. It was Leisha who said, "Look at this guy." And that's when I met Floyd. He was the same as we all know him now, but super-skinny and all his hair around his neck was gone. He was miserable. But he comes over and sticks his paws through the cage and that was it. Pure love. And Leisha goes, "Kate, that's him." And I said, "Yup, that's my guy." I threw my name down on the list and said, "That's my dog." ■

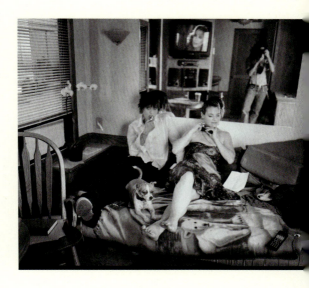

Laurel Having my dog at work was great the first season because basically we were treating her like our child. Unfortunately, once we had our first daughter she got bumped down. My dog Josey was in love with Kitty [chief hair stylist Paul Edwards's dog], and his dog was this fancy white Scottie that always arrived in a Louis Vuitton doggie carrier. Josey loved Kitty. I think she wanted to be Kitty ■

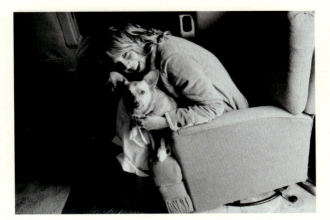

JOSEY

105

Pam Some cast members brought their family of dogs up to location. I brought my horses to ride and not be alone. A little bit of home was with me. I live with dogs and needed them to remain home to watch the house and livestock ■

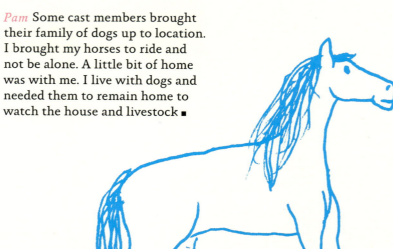

Leisha [On getting Rainbow, Mia's dog] Well, Rainbow's a big story. I feel like Mia and I have very good, like, big story plot points of our relationship and Rainbow's one of them.

Mia We do. Should we talk about—where should we go back?

Leisha I went many times to the pound with Mia to go look for a dog, and there were always little ones, and I was like, "That's the one. That's the one." And eventually you fell in love with a dog that grew to be seventy pounds.

Mia We went back to the pound and the manager of the pound had said, "There were these dogs that just came in that were just on television because we were trying to foster them off. There are two of them. How would you feel about fostering a dog?"

Leisha And they had them in their little workstation, right?

Mia Yeah, and they were running around. Rainbow was like, that big, and I was like, "Leisha!" and what was your—

Leisha I panicked because I know Mia, and you know, she travels a lot. A lot. So, I went into a full-blown friend panic as we drove—I think after you got Rainbow.

Mia Well, first I was going to get her brother, and remember I did the food? I put food in both hands, and the brother bit me, and Rainbow licked it off me gently so I was like, Rainbow is the one.

Leisha Right, and then you had her for a couple days, and you got anxious about it.

Mia Yeah.

Leisha That's when you called me, and I was like maybe you should—

Mia And I was like, "No way! She's mine."

Leisha And you were upset with me.

Mia Yeah.

Leisha Like, "How dare you tell me not to—"

Jennifer Because you said maybe you should take her back?

Leisha Well, no because there was a mother and daughter who wanted her that day we were there at the pound and they said, "If you don't want her, call us."

Mia Well, she definitely changed my life.

Jennifer She's such a beautiful dog.

Mia Like, she really—she's made me stop traveling as much as I do, and she comes with me.

Leisha She grounded you.

Mia She definitely grounds me. I mean, she's my best friend. Her name was supposed to be, not Rainbow, but Lavender Plum, and you came up with the name Rainbow.

Leisha Well, yeah, Rainbow Brite.

Mia It was Rainbow Brite?

Leisha Yeah, and you were like, "I like Rainbow."

Mia [Looking at photo] Oh, is she shaking a paw? See, she was so good like that. Look at that beautiful smile ∎

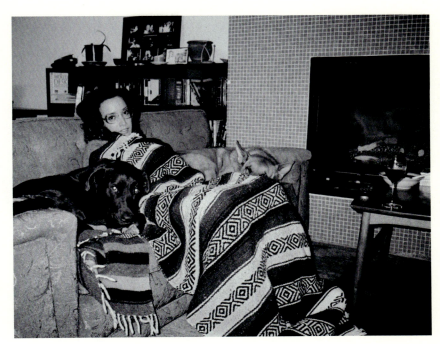

ME WITH MY DOGS, SURVIVING SECOND SEASON. NOTICE THE WINE GLASS AND BOWL OF OATMEAL ON THE TABLE. I WAS WATCHING EITHER ANGEL *OR* BUFFY.

HENRY

Erin I loved having Henry at work. Having him and having Max. It was so comforting to have him there. Yes, he's my dog, but he's a very old soul. He's got such personality. They both do. They are both so not dog dogs. They're like people. Henry in particular. Henry can talk. If he wants a treat he doesn't bark. He looks at you and sits down and starts going "Wahahhh, wahnn, warn . . ." like he's trying to reason with you. He looks at you like, "Why can't you understand what I'm saying? I mean I'm just saying to you very clearly if you give me a treat I'll give you a back rub." You know? He was a piece of home ■

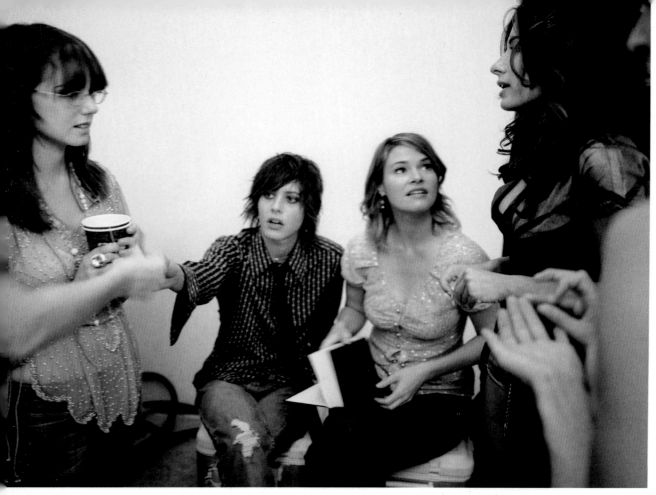

SEASON TWO POSTER SHOOT

AT MIA'S HOUSE IN LOS ANGELES

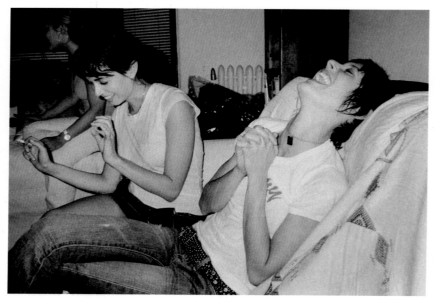

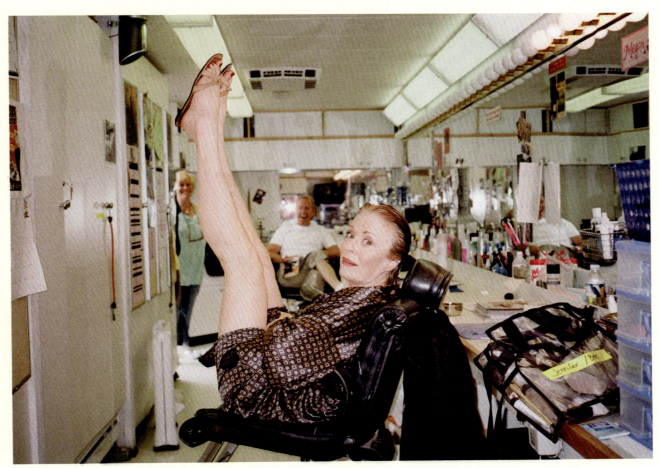

HOLLAND TAYLOR IN THE MAKEUP TRAILER

LAUREL (AND LOLA) IN MY TRAILER

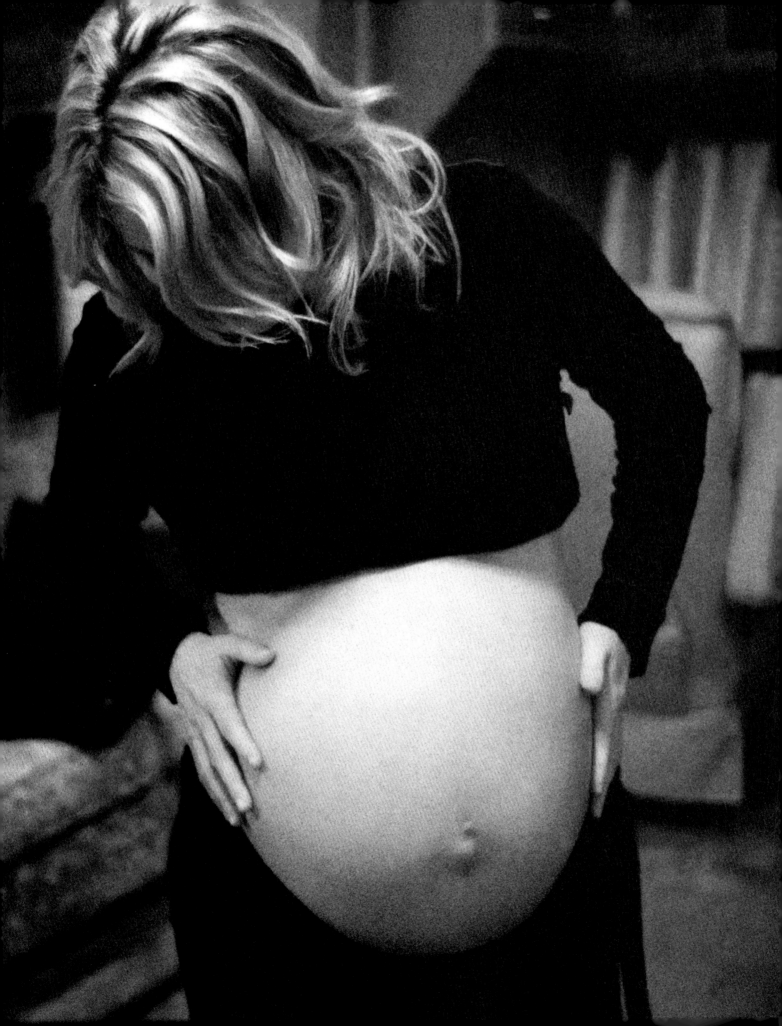

MEETING LOLA

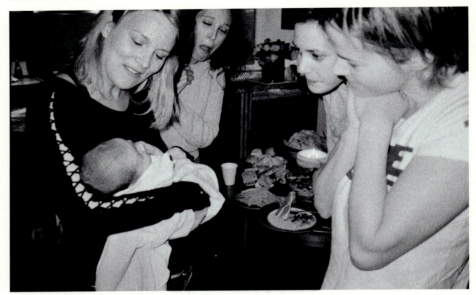

Jennifer I remember when Laurel went into labor. I was at the studio, shooting, and I couldn't concentrate, I was so nervous and excited. I couldn't sit, I was in perpetual motion. I would check my phone constantly, resisting the urge to call her or Paul, her husband. I would run back and forth to the office to see if they had gotten any word. I couldn't take it—I could barely breathe. I wanted the baby to be healthy, I wanted Laurel to be safe and happy. When I heard her daughter had been born safe and sound and that everyone was okay, I fell over in my trailer from exhaustion and wept. We had spent so many weeks and months talking about having children, and now she was a mother. A luminous door had opened for her. And in some way, by her going first, I felt she had paved the way for me. I would be forever grateful ■

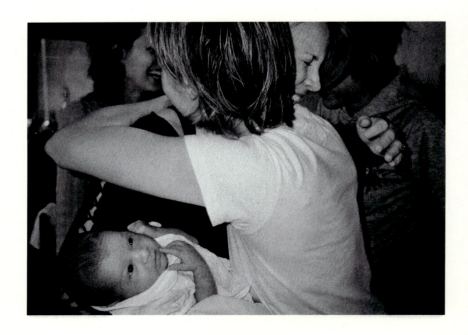

THE QUILT

[Before Lola was born I secretly asked the cast to help create a quilt for her birthday. Each section of the quilt would represent a quality the cast member wished for Lola. The quilt would be like a hope chest. Each cast member was responsible for making her own section.]

Mia I didn't know about babies at the time.

Leisha [laughs]

Mia And I sewed a photograph, the Polaroid, to the quilt.

Leisha With lots of black Sharpie. It looked like a prop from a horror film.

Jennifer . . . the black Sharpie nightmare sequence. [laughs]

Mia Where is it?

Jennifer Laurel has it. But I remember . . . didn't I send your square back to you to . . . ?

Leisha [laughs] It was a redo.

Mia I got really frustrated.

Jennifer It was a redo, it was a redo! [laughs.] And then you had, did you have Deb [our truck costumer] do some of it?

Leisha You probably had someone else make it.

Jennifer Didn't you bring the stuff in to Deb to do it?

Mia I just was like, "I don't know how to use a sewing machine, I don't understand why I can't use the photograph, the Sharpie's not right either." Like it was all wrong for a baby and I was just so upset by the whole thing and you were really upset with me and I was trying really hard.

Jennifer It was handed to me in a brown paper bag, as I recall.

Mia It was?

Jennifer Yes. Brad [our assistant director] handed it to me. "Mia left you this." There was a brown paper bag. And I opened it and I was like, "What the hell?!" [Laughter.] It's a toxic Polaroid . . . It was beautiful, I have to say though, it was beautiful. It was a work of art, but NOT for a baby.

Mia It was totally inappropriate for a baby.

Jennifer But it worked out because it went on the pouch that carries the quilt.

Leisha You're so crafty, Mia.

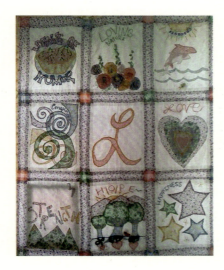

Erin What an amazing thing that quilt was. I think about that quilt every so often, especially since I just had a baby. Just like what an amazing gift. Because it's not so much the thing that was given to her—it was like the time and the thought and the process that everybody went through because everybody CARED so much, y'know? It was amazing and that's what the experience of *The L Word* was to me. It really was ■

THE L WORD "Latecomer" FULL

5 CONTINUED: (3)

 ALICE (
 It's not right and
 to make you feel be

 DANA
 What's going to make
 better, Alice? Dyin
 do that.

 ALICE
 That sure wouldn't
 better.

 DANA
 I'm disappearing, A

 Dana leans into the mirror, ru
 are falling out, too.

 DANA (CO
 Disappearing.

6 INT. BETTE AND TINA'S - BEDROO

 BETTE crosses away from the cl
 clothes on hangers. Intersect

UE August 15, 2005 Pg. 8

NT'D)
s not going
r.

e feel
Cause I could

e me feel

e.

at her eyebrow. Those hairs

'D)

_ MORNING (D1) 6

et, carrying an armful of
ith TINA, entering empty

Daniel Sea Arriving in Vancouver, auditioning the week beforehand, and finding out the day before I came that I had gotten the job and it being my first major acting job since an independent film where I had ONE scene, I knew had a lot on my plate. When I arrived, it was a bit overwhelming, even the studio—a huge soundstage and tons of lights and a hundred people working. My first impression was that everybody was pretty cordial and welcoming. And I was filled with this adventurous feeling that I've only ever had when I'm traveling in other countries or learning instruments or something where anything is possible. And when you're in that frame of mind the lines of fantasy and reality tend to get blurred. I was in it for the full experience. And when I first got hired, I didn't know Max would be a transgendered character. Ilene chose to hold off a week or two to tell me that. I wasn't anticipating any long journey for this character. I figured I might come on for maybe six episodes or less. I didn't really understand the weight of what happened culturally and how our characters in the story would effect change in the general culture as far as trans visibility. And I also didn't know that Max would only temporarily tell this working-class story within the friends that we got to see in the "Lobster" episode. I really enjoyed tackling this often untouched story of class friction among friends ∎

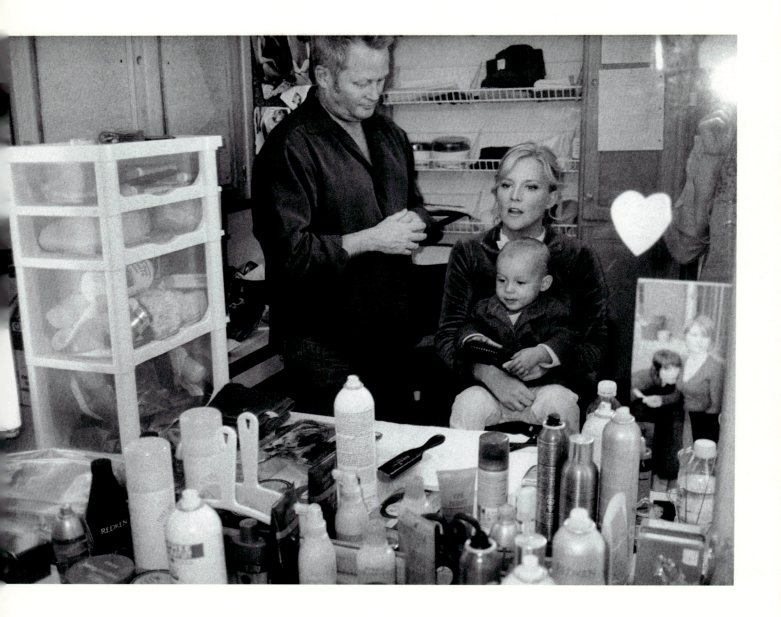

Laurel I would have to say I loved my makeup trailer because it was quiet and calm, and I felt I got lucky because it was a more relaxing trailer, which is what I needed. It was also such a fun place to bring my kids. Both my daughters loved it in there. My oldest liked to dress up with the wigs. I also loved the other trailer because it was fun to go in and visit with everyone. It was the makeup trailer to go chat and gossip in, and it had a pulsing energy to it. If I needed to catch up on the gossip I would always go into the main trailer. They had all the great fashion magazines, too. All in all, I felt like everyone in the hair and makeup department rocked. When you are an actress, they are like your family. And we had the best of the best. They see you more than anyone and they see you in every mood. They truly are the people you get closest to and they work so effing hard. I miss them the most now that it is over ■

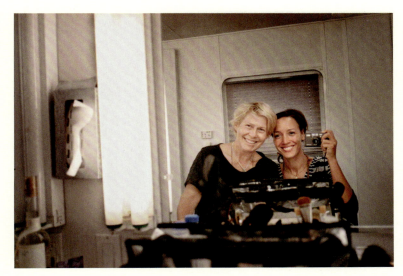

ME AND JOANN IN THE MAKEUP TRAILER

Mia It felt like the two makeup trailers were like different dorm complexes. One was quiet and for the good, super-smart students. The other one felt like the party house, with chaos, dancing, half-eaten breakfasts, and the place to be when you felt in need of connection. Paul Edwards and Joann Fowler (hair and makeup) were the glue of the cast who lived in the loud trailer. Without them, I would have never survived work on the show ■

GARY LEVINE, PRODUCER. SEASON PREMIERE, NEW YORK

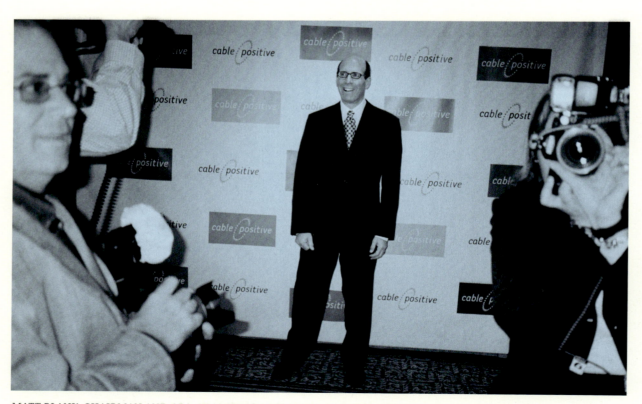

MATT BLANK, CHAIRMAN AND CEO, SHOWTIME NETWORKS. CABLE POSITIVE LUNCHEON, LOS ANGELES

THE DETRITUS OF ME GETTING READY FOR A PRESS EVENT

MY PUBLICIST'S OFFICE, LOS ANGELES

Jennifer When Laurel got pregnant, having Lola—it changed everything for me on that set. Maybe it was because I wanted to have a baby too, but it felt like even more of a tribe. I loved that.

Leisha Yeah, for sure. I know what you mean.

Jennifer The circus felt more like a little tribal camp with babies and dogs and—

Mia Laurel was amazing during her pregnancy. Like, she really seemed unfettered by the fact that she was pregnant, and she worked right up until the end.

Jennifer Oh yeah. She worked an eighteen-hour day before she gave birth or something crazy, and she was so strong and so determined to do really great work, and really brave, whereas when I was pregnant I was like, "Where is craft service?" [laughs] ■

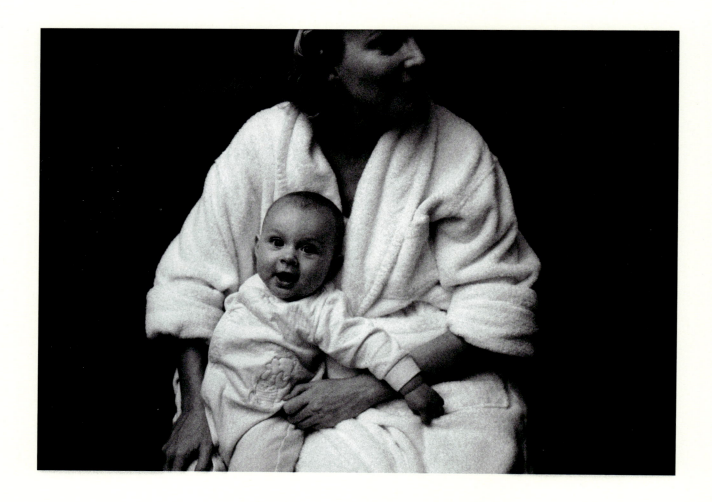

Laurel It was like a family that just functioned and sometimes dysfunctioned together.

Relationships just evolved and flowed but the core group felt like a family. I remember thinking it must be hard sometimes for new people. We were tight. Very tight ■

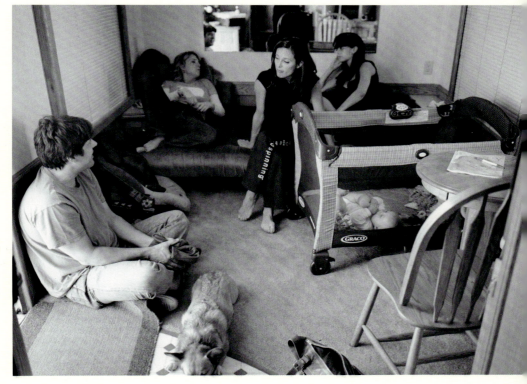

LAUREL'S TRAILER

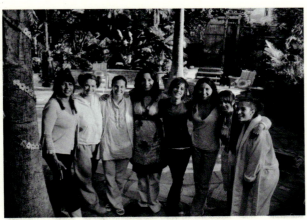

Jennifer This is from the patio party scene at Bette and Tina's house in episode 307. Bob Aschmann took this photo. The instant I wrapped the scene I got in the car with my husband and two dogs and headed back to Los Angeles to await the birth of our daughter. The car was packed with all our things from that year; the dog food, dog toys, and every imaginable snack for my sometimes ravenous hunger. As much as I loved the cast, the show, Vancouver—the moment we crossed the border I felt free ■

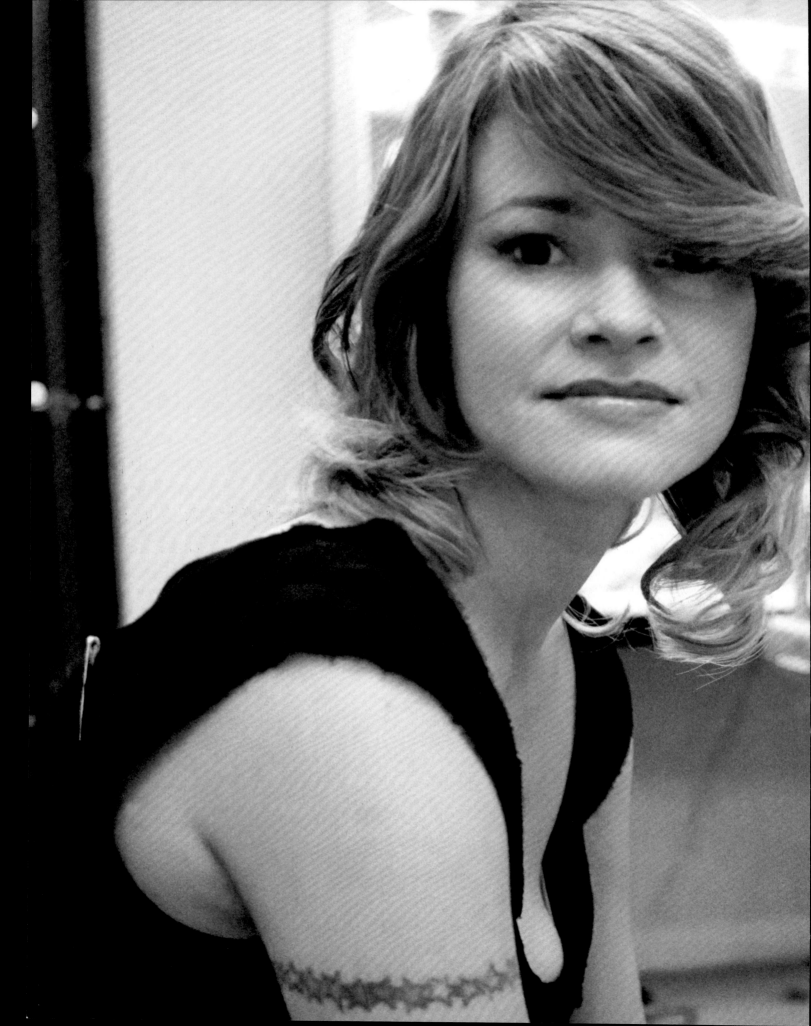

August 9, 2005

Jennifer,

Enclosed please find a CD with two guided meditations. For our purposes, I recommend you listen to the Heart Meditation because it has more imagery. I don't have a CD that has the exact meditation that is written in the script, but I hope that this gives you more of a sense of it. When you read the new draft of the script, you'll see that I've revised the scene and simplified it a great deal. I've taken out the most surreal imagery and brought it more to breathing and relaxation. Bette simply leads Dana to envision a peaceful place, and the rest is left to Dana. We establish now, explicitly, that the meditation Bette does with Dana in 307 has not to do with her own meditation practice but rather to do with a practice that's done by therapists and clinicians to help sick and grieving people. For me, this scene still resonates with Bette's own practice but no longer conflates with it. I think it will work powerfully in the episode. It portrays Bette as a compassionate friend who has the insight to know what will soothe Dana in a moment of great distress.

I'm sorry I wasn't able to address all of your wishes in this script. My choices weren't made cavalierly. In reviewing the episodes leading up to this one, I'm confident that we've established Bette as a devoted and loving parent. I added the scene before you go to the

concert (with some additional beats in this latest revision) to underscore. It was equally important to see you come through for your sister, and to see as part of the ensemble. In the next episode, Bette goes away on retreat. We won't see you with the group again until episode 311 or 312. The beat in which you learn that Tina is with Josh is vital to the drama (and it was absolutely vital to the network), and this was the best way I could devise to play that moment.

Please let me know if you want to talk any further about this material before we shoot it.

Best,

Ilene

Erin Cora [a healer] helped me out third season when I was going through everything. I was letting go but trying to stay engaged as possible with the character by trying to maintain my personal health because I didn't want to take on that energy. And I worked really hard at maintaining my separateness from the character that season. No matter what time it was—2:30, 3:00 in the morning— when I got home from set I would still take an Epsom salt bath and meditate because I HAD to. And I could feel it. It was like I had to suck the toxicity out of my body before I went to sleep, otherwise I would—it would stay and I would get sick, I just knew it. And I worked with Cora on channeling that through my body, by expelling it as well, and it was really powerful ∎

Erin I was so sad. My last read-through was—to be perfectly fair, to be really honest, I was angry. I was hurt, so I was sad about it. But there were so many emotions. I remember thinking, "Well, that's that." It was really sad. I wasn't the only one I remember who was very sad that day. There was a piece of me that was so angry about the whole decision. It just felt so unfair and I never understood it. I never asked, "Why me?" I know they were hell-bent on telling that storyline. That's what I was told.

Jennifer I think if Ilene had to do it all over again, I don't think she would have killed the character.

Erin I don't think so . . . I grew up a lot during the show. I was in my twenties when I started the show and I was in my thirties when I finished. My priority was my career when I got the show, and by the time I left, my priority was my life ∎

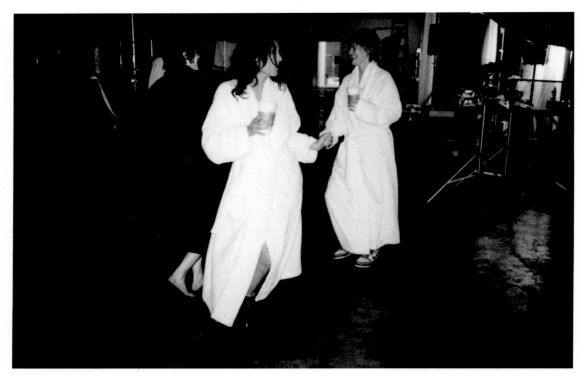

KATE, ERIN, LEISHA, PHOTO SHOOT

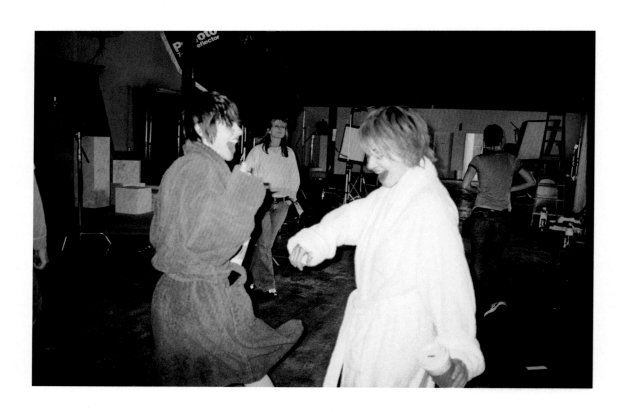

Jennifer What was your favorite season as an actor?

Leisha Weirdly, it was third season because I felt like it was the first time it became obvious they were giving me more to do. And with Erin, they really focused on sort of cutting to us for one funny scene and then they actually gave us something to sink our teeth into. And we all know that was the season Erin [Dana] died, so it was challenging as an actor to have to play that.

Jennifer To me one of the most memorable scenes of the entire six seasons was when Alice breaks down in the hospital corridor after she finds out that Dana has died.

Leisha Really?

Jennifer Yeah. For me it's one of the most amazing scenes in the whole show.

Leisha Well, Rose Troche shot that. That was her episode.

Jennifer I can't even really watch it anymore, it's . . .

Leisha I can't watch it anymore either. I've watched it and I cry every time. It was too hard that day. It was way too hard. Saying good-bye to my friend.

Jennifer And in a way it was kind of like saying good-bye to Erin, too.

Leisha The reason I felt it was so easy to break down for me and have that moment was because I really was losing my friend. I mean it felt like a death in a weird way. It felt like saying good-bye to somebody who I loved just as deeply as Alice loved Dana. It was the end of a chapter and I knew I wasn't going to see her. I mean at home eventually I would but . . .

Jennifer But not in the same way.

Leisha No. The life that we all built together up there, I think it was forever different after that day.

Jennifer I do too. The show changed after that day, and I don't know if it changed because the writing changed or we realized that the group could never be the same.

Leisha Right. It was something we all started together. When people start falling off, it just shifts the whole dynamic of the show.

Jennifer Well, just like when somebody passes in your life, when somebody passes in your circle of friends, you love the people that are still there, but the group dynamic is just different.

Leisha Exactly ∎

season 4

HOLLYWOO
Gay people are opp
hugely discriminat
society. Gay right
the new civil righ

TINA
That's why it's so
this movie gets m
and representatior

HOLLYWOO
Yes, but the story
about who's sleepi
what designer shoe
trivializes the st

Jenny is clearly insulted.

JENNY
My story celebrate
sexuality in a wor
to acknowledge tha
shatters the stere
as sexless, unstyl
wear flannel shirt
level haircuts.

Tina tries to catch Jenny's
easy.

DIRECTOR #1
sed. They're
against in our
is absolutely
frontier.

mportant that
. Visibility
re--

DIRECTOR #1
s too much
with whom and
she wears. It
ggle.

female
that refuses
it exists. It
ype of lesbians
h creatures who
and have bad bi-

e, gestures to her to take it

Jennifer You and Leisha worked so well together.

Rose Rollins Yeah, and I feel that like that's actually what kind of almost lost me the job in the beginning, because you know they made me test twice, because Leisha came and read with us, and I guess Tasha was supposed to be really hard and unavailable. But once we started to, once we started the scene we kind of like—everyone else disappeared and I wasn't nervous for the first audition ever. Like we were just talking and I really, really, genuinely liked her and so then they felt that I was too soft, you know, like I wasn't—so it was really, really weird.

Jennifer So then for the second audition how did you prepare?

Rose Yeah, well, then Ilene had to tell me what—because Showtime had already signed off on me and they said, "No, she's too soft, she's not hard enough or not butch enough or whatever." But then Ilene just said, "Look, you gotta just really play up the hardness. Don't take her in so much. Just kind of ignore her."

Jennifer Right, right. Don't be charmed by her, by the Leisha Hailey–ness of it all.

Rose I know, I know. Yeah, so I just totally ignored her and that was it.

Jennifer And what does Leisha say about you totally ignoring her, during the audition? Did she know what was going on?

Rose Oh, she knew what was going on because she actually was one of the main people that couldn't understand why I didn't get it. Like, "You have to bring her back," so they kept me on hold, and they opened up the testing again. Yeah, so she knew, she knew that Ilene was going to give me the talk.

Jennifer So she was prepared for you.

Rose Yeah.

Jennifer Then cut to read-through, and you guys can't stop laughing ∎

READ-THROUGH

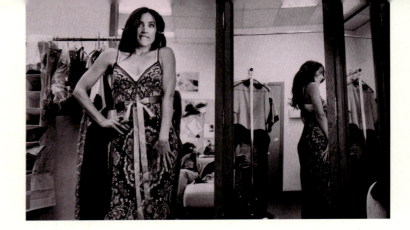

Rachel Straight off the plane and on my first afternoon in Vancouver I had a costume fitting in the production office. I was meeting people at a rate of five per second, but Cynthia Summers, *The L Word*'s costume designer, stood out. With her open, clear face and glittering eyes she has the look of an innocent child. She definitely still has the uninhibited imagination of one and expresses her joy and love for all things beautiful with childlike glee. It's contagious. You'd arrive at Cynthia's office to find treasure chests of splendor and booty, glittering and opulent, silks and calico, jewels and precious metals—and that was just the shoes. Some items, one-dimensional on the hanger, would intimidate me before I tried them on; but I quickly learned to trust Cynthia's eye and would be bowled over at my transformation into a bona fide fashionista. At first I was just a little girl dressing up. I'd never taken much interest in fashion labels before. But regardless of previous knowledge, we all learned fast amid such abundance, and soon we were "label-assaulting" each other (a phrase Rose came up with, I think), nosing about in each other's closets, making special requests to Cynthia, creating looks ourselves and buying more and more of our wardrobe at the end of each season. We became au fait with Diane von Furstenburg, Miu Miu, Prada, Costume National, and Cynthia's own favorite, Marni. We were totally and utterly spoiled by the costume department, and we had the wonderful Cynthia to thank for all of that ∎

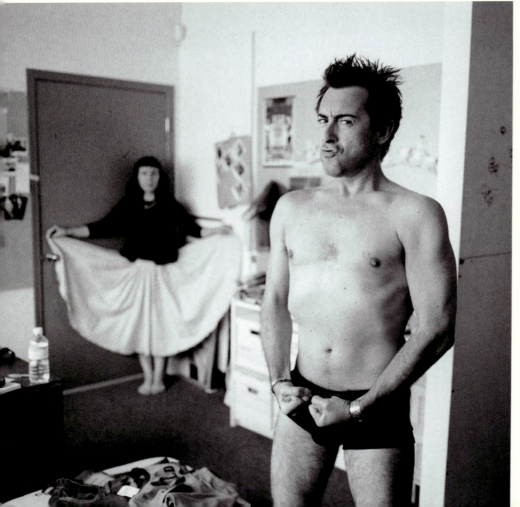

ALAN CUMMING WITH CYNTHIA, FITTING ROOM

MARLEE, FOURTH SEASON POSTER SHOOT

Marlee Matlin You really delved into your character and sometimes I tried to get you out of it, or snap you out of it when you were in character and I felt, in my opinion, it wasn't the time for you to be in Bette mode . . .

Jennifer I think I was definitely bossier when I played Bette. [laughs]

Marlee I'd say something off the point, or crazy, and you would snap out of it, snap out of Bette.

Jennifer And we'd start laughing hysterically, which is why we could never get through a love scene.

Marlee Exactly. But I always looked forward to the two of us working together, whether it was a scene where we had to fight, or just having a conversation, or a love scene or whatever. The time of us working together was always very precious to me.

Jennifer Me too. It was honor for me to be able to act with you, and to spend time with you as a friend. We've known each other for so long, from the very beginning of our careers, and yet we've never been able to spend long periods of time together. It was a treat to be with you. And a relief to be with a friend who knew me before "Bette." ■

JESSICA CAPSHAW

the L word

L WORD SEASON IV PRODUCTIONS INC 8275 Manitoba Street Vancouver BC V5X 4L8 phone: 604-419-1300 fax: 604-419-1301

MEMO

DATE: JUNE 13/06

RE: CAST BASKETBALL PRACTISES CONFIRMED

FROM: Jeff Wonnenberg

TO: Jennifer, Laurel, Mia, Kate, Leisha, Pam, Rachel, Janina

CC: Ilene, Rose, EZ, Kim, Christina, Deana, Joanne, Sandra, Rob, Deborah, Aaron

Basketball practice has been arranged for the following dates/times:

- Wednesday, June 14/06 - 7:45pm to 9:45pm
 @ the YMCA, 955 Burrard Street, Vancouver
 (about a block south of the Sutton Place Hotel,
 please see attached map)

- Thursday, June 15/06 – 2:00pm to 4:00pm
 @ Simon Fraser University, West Gym, 8888 University Drive, Burnaby
 (please see attached maps)

- Monday, June 19/06 – 2:00pm to 4:00pm
 @ Simon Fraser University, West Gym, 8888 University Drive, Burnaby
 (please see attached maps)

If you have any further questions about these lessons, please contact me in the production office. Cheers,

Jeff Wonnenberg
2nd Assistant Production Coordinator

8275 Manitoba Street. Vancouver, B.C. V5X 4L8
Tel: 604. 437.3740 Fax: 604. 437.3745

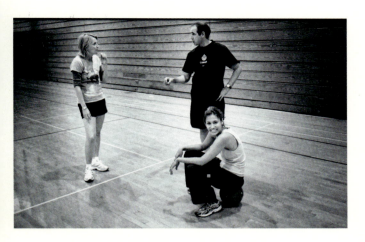

Kate I never went to one basketball practice. I always said, "Yeah, I'll be there," and never went.

I know how to dribble. [laughs] Not to mention someone told me Shane wasn't even gonna care about playing ■

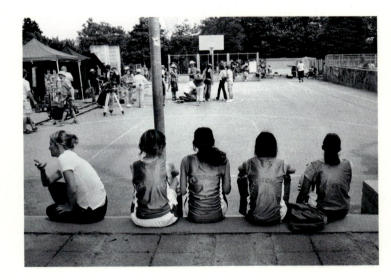
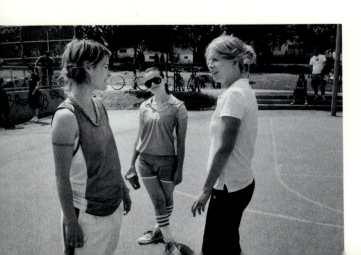

OURCHART PHOTO SHOOT

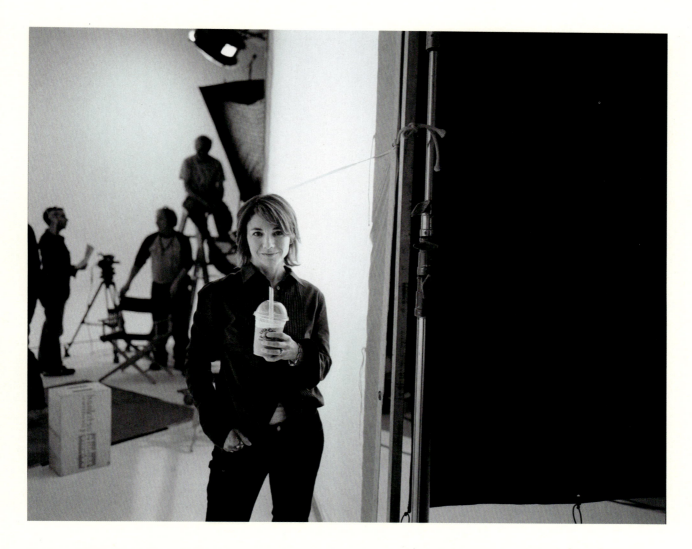

Jennifer When OurChart was created what had you hoped OurChart would do?

Leisha I liked the idea of fantasy turning into reality. I liked that it was going to cross-communicate between the show and the website, and I really wanted the community to have a place to go because there were so many offshoot websites and we could take this and make it a site we would want to go to.

Jennifer Do you think it accomplished anything?

Leisha I mean, quite honestly . . .

Jennifer It certainly accomplished bringing people together.

Leisha I really was interested in giving women writers and directors a place where they could post their creative projects. A vehicle for art in a way, for women. But I don't know if it ever really did enough of that.

Jennifer I just thought it was really amazing how people could come together on the Internet—God I sound like such a grandma—how you can get so many people together. It was funny to me how I was the hesitant one to join the group, to join the venture, because I didn't understand what my place would be as a straight woman. I mean I barely knew how to utilize the Internet and am deeply suspicious of its ramifications regarding privacy, but Ilene told me I was still part of the community, in a way. I ended up figuring out how to use it to raise money and awareness for the triathlon and other things. It was kind of miraculous for me, the hermit, to find myself addressing people online. I'm still not used to it, but I see its value. I was surprised by how many people you could reach and how quickly communities could form ■

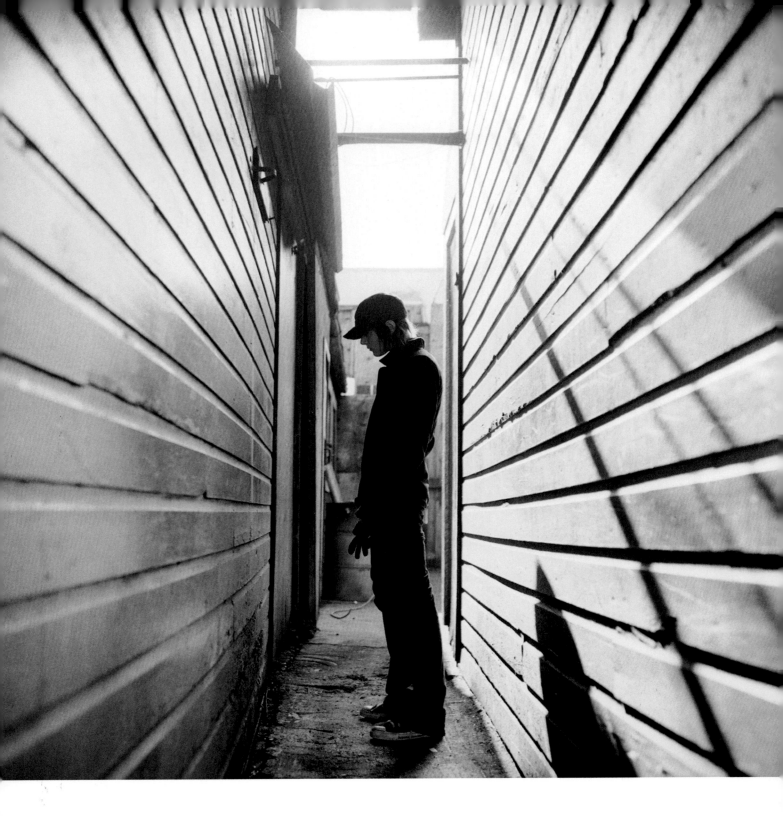

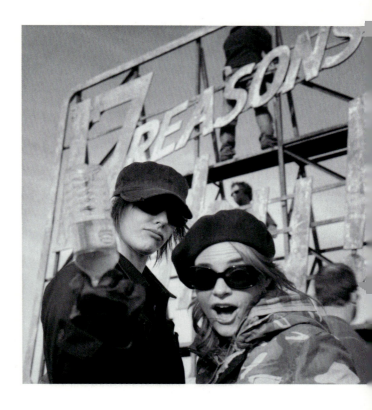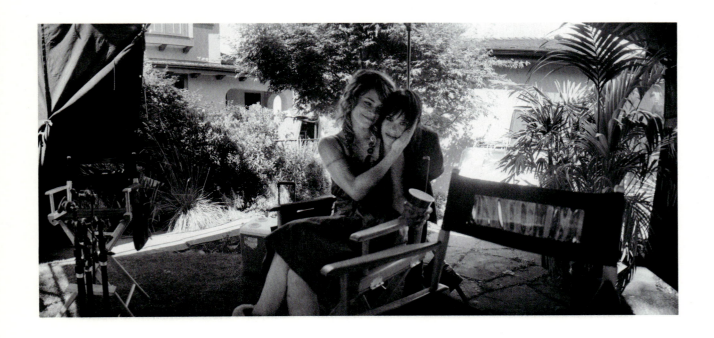

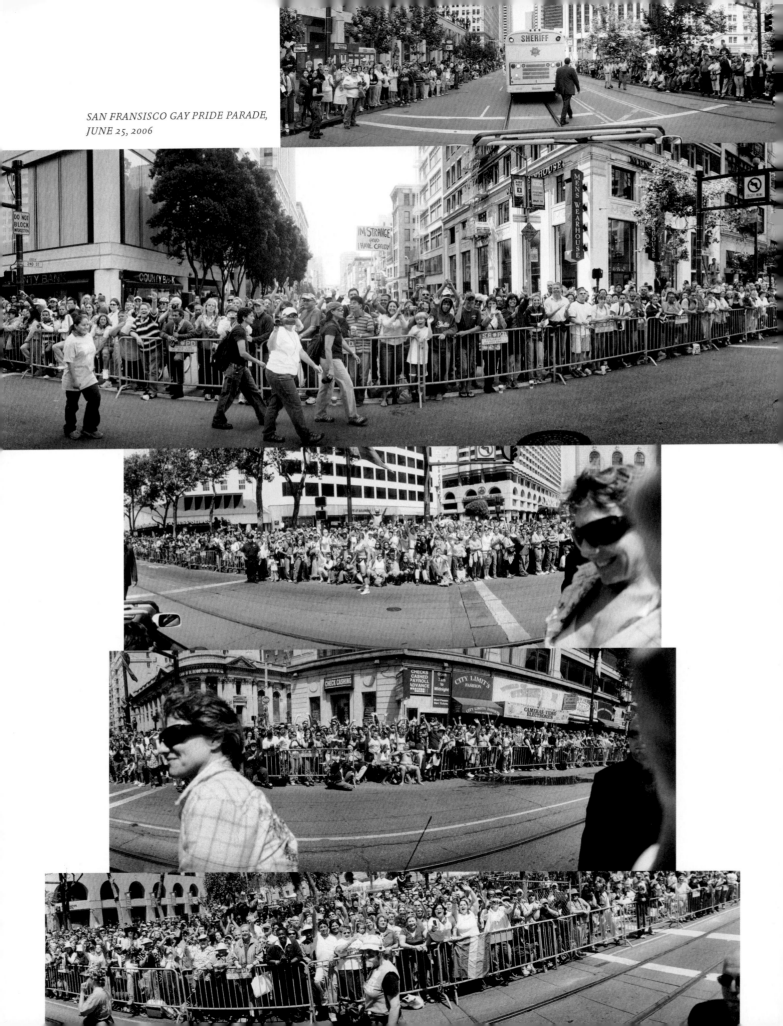

SAN FRANSISCO GAY PRIDE PARADE, JUNE 25, 2006

JB PRIDE SPEECH

1

What a parade, San Francisco. What a gorgeous, glorious, gay gathering. What a celebration of pride and liberation and diversity and love. No other city does love like you do it here in San Francisco –with your architecture, your hills and bridges and your spectacular mayor who stands brazenly in the face of the most archaic administration in modern history. While so many politicians seem to be pushing the politics of hate Mayor Newsome advocates for the politics of love .

2

As I rode down Market Street, I was surrounded by it – love – in every variety, in every race and class, every size and shape, every language and orientation and allegiance. This is a city that revolves around love, where multitudes have congregated explicitly because love is irrepressible. This is a parade that shouts out the power of love even in the faces of fools who would try to suppress it. I'm incredibly moved, right now, to be looking out into this vast sea of love, and grateful and privileged to represent one small facet of it in my role on The L Word.

3

Sometime in the spring of 2002, I was hiking, thinking to myself, "What do I want to do next?" And I thought "I want to do a love story. I want to do a great, wonderful, deep and profound, full of obstacles,ultimately triumphant love story." I made my wish and kept walking. A week later Showtime called me and asked me to join the cast of their new series, portraying a woman loving woman. Wow. Count on the universe to take what you wish for and toss it back at you with much more profundity and complexity than you ever could have possibly imagined in your wildest dreams. I'm still thanking the universe.

4

For me, this parade today is a continuation of that same walk I began those five years ago. And today I make the wish that we take this parade -- we take this pride and this love --.with us into tomorrow and the next day and the day after that. Love is and will always be more powerful than hate. Thank you, San Francisco, for letting me march in pride and solidarity and joyful conviction and triumphant love with you today.

WARDROBE'S CHARACTER BAGS

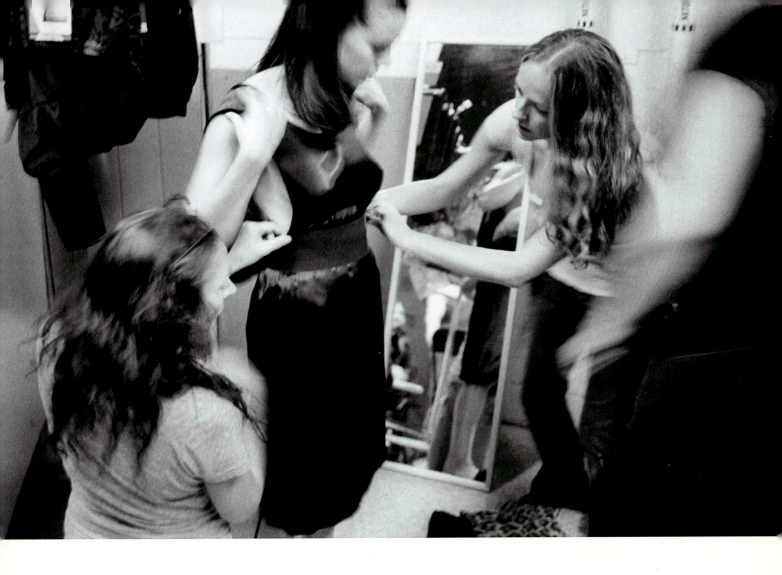

FOURTH SEASON POSTER SHOOT

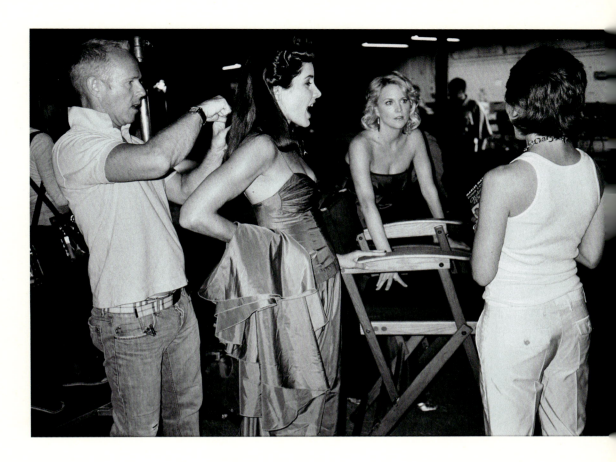

Rachel My favorite episode was the one in Whistler, end of season three, but it felt more like the end of season four, because we shot it in December. We were all staying in a great hotel, with great rooms, and lots of time off to enjoy the location. I had skiing lessons, treatments at the spa, went zip trekking. The evenings were always sociable at the bar, and just being there in the mountains with all that snow and beauty was invigorating and inspiring. Both Alex Hedison and Holland Taylor were there and I always love working with them. I remember laughing a lot during the hen-night scene—a never-ending night shoot that sent us all a little crazy. And singing my heart out on the ski lift with you. I think it looked pretty great in the end result too.

Jennifer When the group seemed at odds with one another or an individual, what do you think brought people back together?

Rachel Usually the work itself. That, and time. It's hard to work as an actor with someone you're at odds with. There's already so much nervous energy and insecurity bouncing around; a fair amount of ego, too. If there are personal clashes getting in the way as well, it can really damage a scene. Consciously or not, people tend to push any personal animosity aside for the sake of the work, and that then bleeds over into your personal relationships ∎

LOLA

season 5

 BETTE
 I know.

 TINA
 It's fun to be dat
 exhausting, gettin
 people...

 BETTE
 Telling your story

 TINA
 Yeah. It's a littl
 lucky to have foun

 They sit there in silence fo

 BETTE
 Yeah, I am.

 One. Two. Three. Bette grabs
 Long, deep, drunken, passion
 around the lesbian world.

 Finally they break away. They
 say a word.

 THE END

. But
o know

er and over.

iring. You're
odi.

moment.

na and kisses her. They kiss.
, careless. The kiss heard

tare at each other. They don't

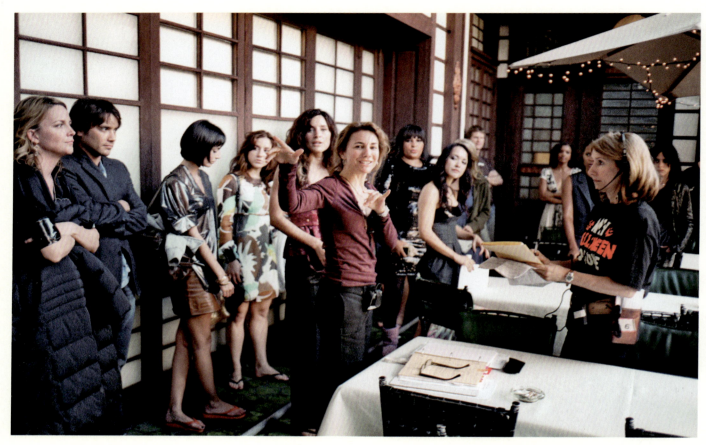

ILENE DIRECTING SEASON 5, LOS ANGELES

Jennifer It's hard to run a show. I feel for Ilene. I think that it's amazing that she got the show off the ground and that it ran as long as it did. And I appreciate her force of will and sticking with it, and including us as much as she did. It's unheard of. Can you imagine being on some huge network franchise and just walking into the head of the show's office and saying, you know I don't think scene blah-blah works? They'd look at you like you were crazy, and you would be fired on the spot.

Rose It's true.

Jennifer I remember when I started working on *Lie to Me*, I just assumed that I would have a meeting with the head of the show. I'm in a wardrobe fitting and I ask, "Is Sam [the show's creator] here? Is the director here? I'd love to go over and sit down with the script and go over my scenes." Just thinking that I'm still on *The L Word* [laughs]. They very generously did sit down with me, but as I recall, they looked at me like, "Holy Crap." [laughs] But that was my experience of episodic television from *The L Word* ■

From: Ilene Chaiken

Subject: script change requests

To: "Ilene Chaiken"

Received: Thursday, July 5, 2007, 11:37 AM

TO: Jennifer Beals, Pam Grier, Laurel Holloman, Leisha Hailey, Kate Moennig, Mia Kirshner, Rachel Shelley, Daniel Sea, Cybill Shepherd, Marlee Matlin, Rose Rollins, Malaya Rivera Drew

As you all know, I am always happy to discuss character arc and stories with each of you and to consider your ideas and make script adjustments based on our meetings and conversations. I also know that it's our 5th season and we all have a shorthand and you no longer need or want to meet with me on every episode and on every script. All good. What's been happening, however, is that those of you who do want to request changes have been waiting until the last minute and conveying them in your director meetings, and that is not working. I distribute scripts on day one of prep so that everyone in every department has ample time to communicate her thoughts. That has to include all of you. It's a huge burden on me and the writing staff to make significant script changes piecemeal and at the last minute. These scripts have been prepped by every department; locations have been chosen; shooting schedules have been worked and reworked; network notes have been addressed. We've churned out many drafts, and by day six of our prep, we need to be able to say that any major issues have already been raised. So please, let us agree that those of you who want to discuss a story line or request changes will do so within the first three days of prep or within the first three days after receiving a script. Feel free to call me or email me if you don't want to come in for a meeting. Just please give me and the other L Word writers the respect and courtesy of coming to us sooner rather than later with your concerns.

With love and affection,

Ilene

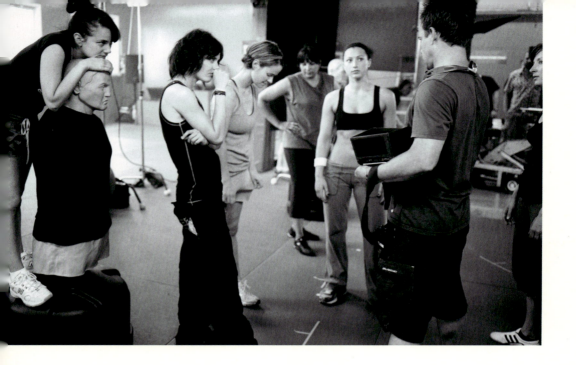

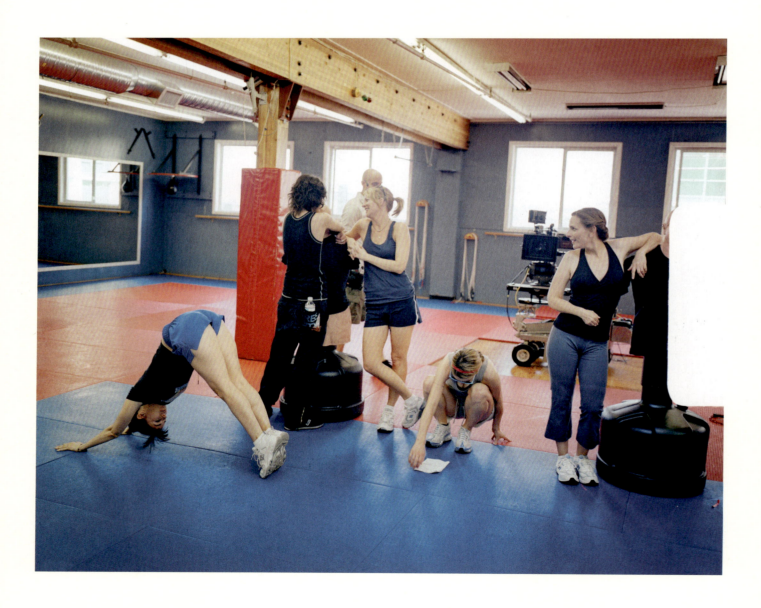

Mia [Looking at photo] Oh my God. What was that?

Leisha That was when you were molesting the toy doll made for stopping molesters.

Mia No, but we had a whole thing.

Mia We had a whole thing about that, like we pretended to be sex instructors.

Leisha That was downstairs.

Jennifer ou were the Russian sex instructor.

Leisha Mia, I still would like to make a short film of that.

Mia What? The Russian sex— what was it? "Okay" [spoken in a Russian accent, claps her hands]

Leisha Like you went over to people's houses and helped couples have sex.

Mia Yes. [laughs] ∎

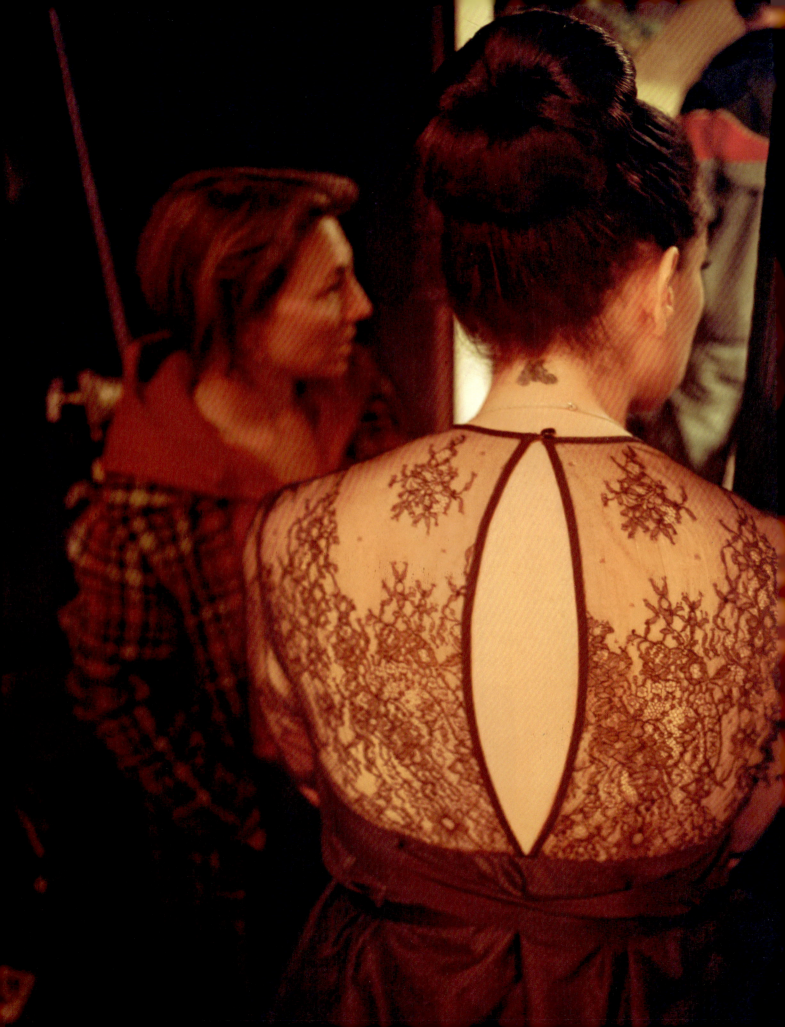

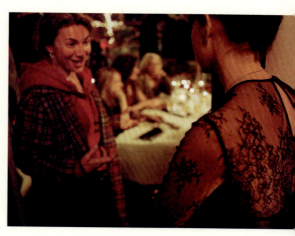

Jennifer [to Rose Rollins] When your character came I remember there was excitement. I remember talking to Ilene about you and your work on *13 Moons*, but EVERYBODY was really excited. Whenever a new person joined the cast, there was always this sort of excitement of "What's gonna happen?" "What are they gonna be like?" "What's their story gonna be like?" How did you feel as the new person coming in?

Rose You know what? I was surprised, and I guess I even thought to myself, "Oh this is what it's supposed to be like when it's just right," you know. It was the easiest job all around that I think I've ever had. Like, I was just comfortable. I jelled well with the immediate people that I worked with. And I wasn't nervous, and I'm usually so nervous about everything, like shaking nervous, like an uncontrollable leg-shake nervous. But I wasn't. I was confident. And I was just there to do my thing. And I also made great friends ∎

Jennifer In what way do you think the friendships that were off the set informed what you did on the set?

Leisha I think the show would have been completely different without real friendships. I think it inspired the authentic quality of the show.

Mia Yeah, but you mean like storywise?

Jennifer I think obviously it was really helpful that you have these real friendships, but then what if when you have this dissension?

Leisha You mean when our characters would do it?

Jennifer Yes.

Leisha It was upsetting for both of us.

Jennifer When your characters didn't get along.

Leisha When our characters didn't like each other . . . Like when it became not funny, we didn't like it.

Mia Yeah, it felt bad.

Leisha It felt . . . it felt like if there was distrust . . .

Mia It was stupid, but I just wanted everybody to get along, for everybody to be happy as their characters.

Leisha It just felt bad. You know . . .

Jennifer Did it ever affect you guys?

Leisha That's what I'm saying—it did.

Jennifer So if somebody was arguing off set, those days were really hard and often the dissension was caused by what the characters were going through . . .

Mia Somebody was always mad at somebody and the general position was I'm not getting involved.

Leisha No, you would do . . . the only time I had that was with you [Mia] and it was when you would do your silent treatment [laughs].

Mia What?!

Leisha And I didn't know why.

Mia What silent treatment?

Leisha Like if you were upset about something and . . .

Mia That's horrible.

Leisha . . . you didn't tell anybody. We'd get to work and you'd do the ice, ice out.

Mia Really? Is that what you called it?

Leisha Everyone was trying to figure out who Mia was upset with.

Mia Was it called "The Ice Out"?

Leisha It wasn't called "The Ice Out", but we, it's like, "I'm getting iced, I'm getting iced!"

Mia Ohh.

Jennifer And I remember the first time I ever saw it, and I don't think I ever saw it very much, was after that photo shoot when we were all naked and you were upset about something . . .

Leisha It was your wig, wasn't it?

Jennifer The night before that photo shoot I passed a kidney stone . . .

Leisha I just felt fat and wanted to be covered more [laughs]. I was just grabbing for anyone's arm or leg to cover me. I didn't care where it was coming from [laughs].

Mia You passed a kidney stone?

Jennifer Yes, it was excruciating . . . It was a crazy shoot. But it's my favorite poster.

Leisha It was beautiful.

Mia Even the bad stuff now I'm beginning to have a sense of humor about ∎

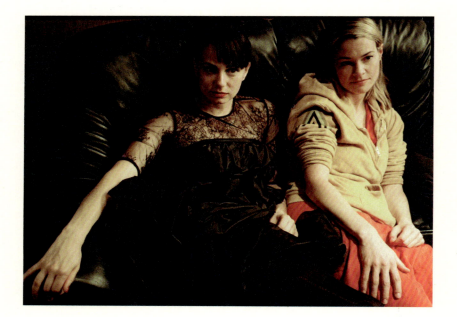

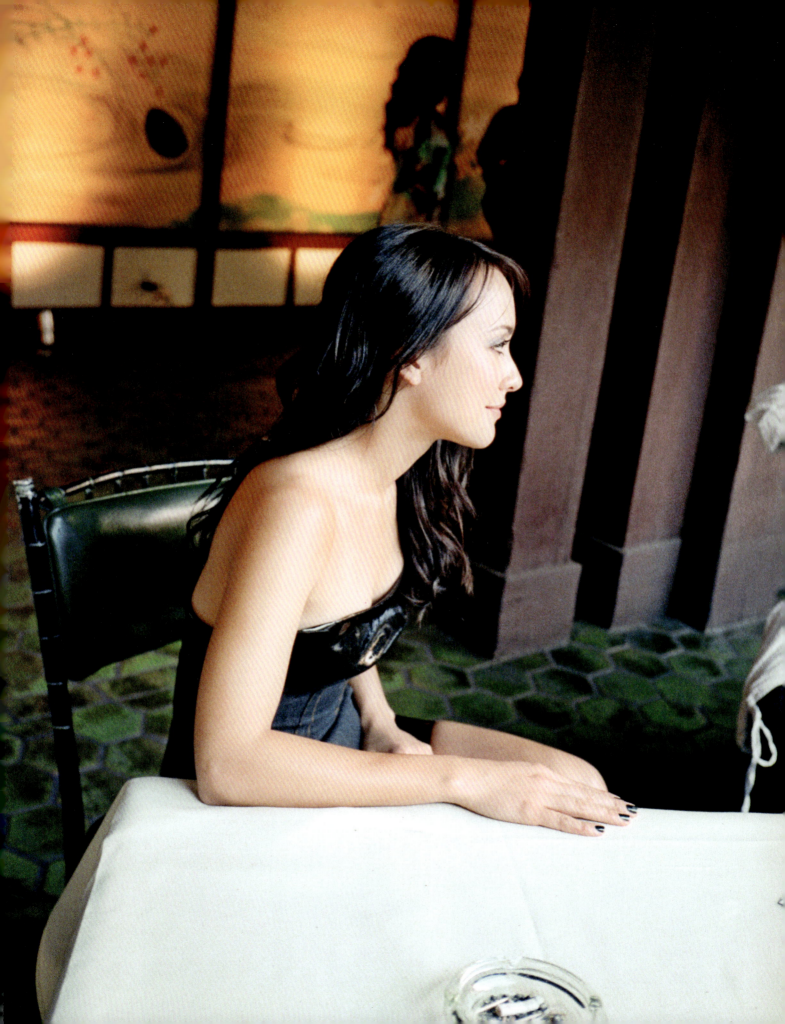

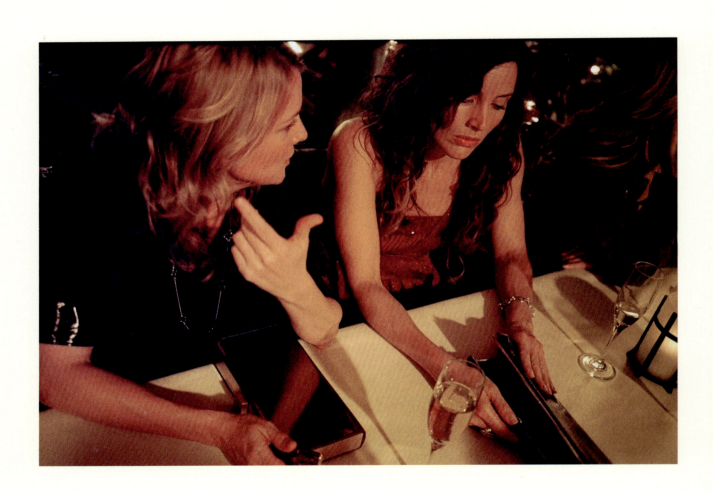

Rachel When I met Laurel Holloman I made two new friends. It was my first day on the set of *The L Word* and Laurel was sprinkled all over with baby dust, literally radiating health and vitality at about five months into her pregnancy. Hilarious, really, as her character was supposed to be successfully hiding the bump from her ex, Bette. But no pink poncho or cleverly positioned hand bag was going to conceal it. Laurel was clearly cock-a-hoop about her condition, and her happy state washed over me and helped calm my new-job nerves. Not only did Laurel treat me like we'd been friends for years already but she made me feel welcome and secure on an alien set. We chatted between takes— she probably isn't even aware how much that helped relax me. Maybe it's that Southern drawl of a personality—to a Brit like me it speaks of reassurance and mischievous humor, a cheeky twinkle in the eye that doesn't take life too seriously. It's safe to say I took to Laurel immediately.

I also took to her bump. Most of my working life that summer was with Laurel, and her pregnancy brought out my chivalrous side. Laurel continued to work throughout her pregnancy, with never a murmur of complaint, and I found her fortitude inspiring. I wanted to help as much as I was able. The little life growing inside her was constantly making her presence known—kicking and even visibly moving through Laurel's sheer silk dress one time during a take. All who saw it gasped. Here was my second new friend. Once little Lola had safely arrived, Laurel flattered me by saying she responded to my voice, apparently after listening to it for hours on set in utero. Lola quickly grew into the most adorable little girl I knew, cute shy shrugs and all. Lola is a chip off the old block and so much fun to be around. She's all smiles and sunshine, just like her mum.

Over the years I have spent some great times with Laurel. We've hiked in LA, whiled away the wee hours in Vancouver while putting the world to rights, and in my hometown of London we danced the night away in Soho, high on the deliciousness of great food and champagne. Great memories.

Now that the show is over and we're all back in our respective countries, I don't get to see Laurel or Lola and I miss them. Especially as now I have my own daughter, I would love to pop round for tea and get some parenting tips from a wonderful mum. Unfortunately, Lola has probably forgotten me, but I'm going to make sure her mother doesn't ∎

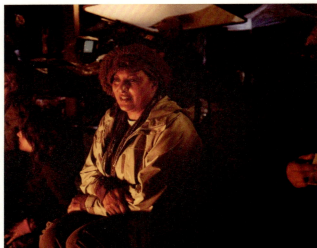

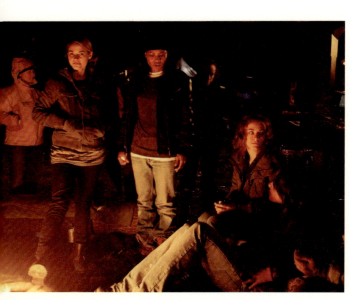

AROUND THE CAMPFIRE, EPISODE 510

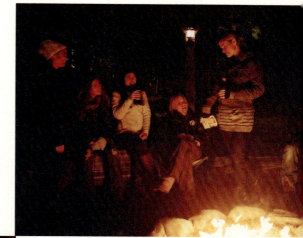
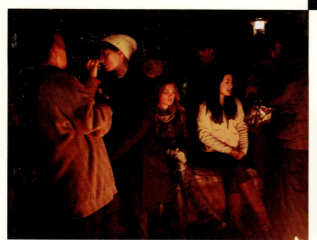

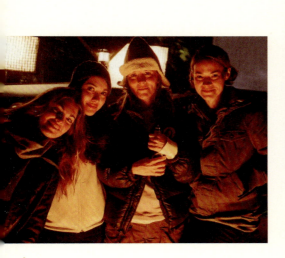
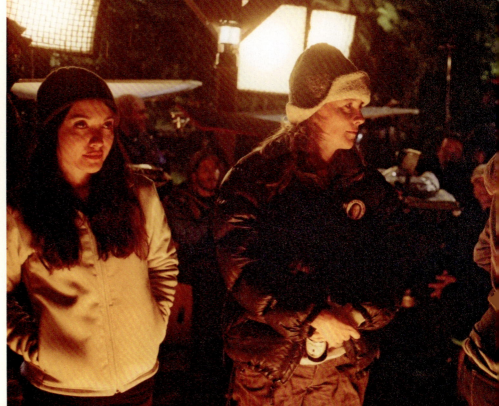

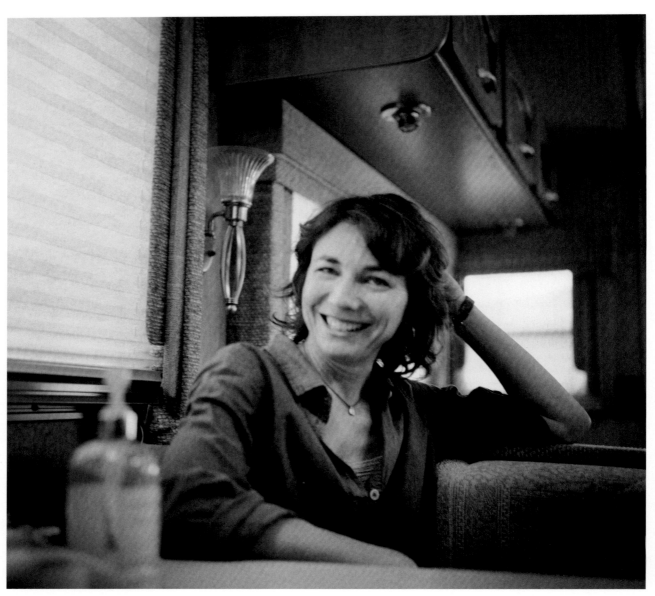

ILENE IN MY TRAILER

10 INT. INTERROGATION ROOM - FL

Kit sits forward in the chai:
eye.

> KIT
> You will never fin
> people who love on
> and who look after
> lovingly as these
> give me any army,
> god, any mama lion
> her baby cubs and
> up against them fo
> and as fiercely lo
> another-- every on
> we've been doing i
> Y'all would be luc
> friends like these
> okay, we've had ou
> here and there. Wh
> little work squabb
> about girlfriends,

> DUFFY
> So not everybody i

> KIT
> How many times do
> you people, it doe
> gay and who's not?
> a question I answe
> people. I let each
> that question for
> she wants to give

FORWARD 10

d looks Duffy square in the

 group of
nother more
e another as
ends do. You
 assembly of
nding after
l put my posse
eing as tight
-- We love one
f us-- and
or years.
to have
iends. Yeah,
ifferences
asn't? Some
or a thing
 boyfriends--

ay?

ave to tell
t matter who's
nd that's not
or other
rson answer
self, and if
ifferent

Jennifer What shows did you watch during your downtime at the circus?

Kate It always varied. First season, Erin, Leisha, and I watched *The Goonies* and anything '80s related. Then we would show up on set reciting these movies' quotes and no one knew what we were talking about. Second season I guess I went solo. Watched *Braveheart* and *Blow*. I also went to the Virgin Megastore and just spent tons of money on DVDs, so by the end of the season when I was packing up I had the biggest DVD collection.

Jennifer What movies specifically?

Kate Fifth season I was into *The Sopranos*. I watched the entire series. The following year, I was like, "Okay, let's watch *Six Feet Under*. The year before that I watched *Freaks and Geeks* and *My So-Called Life*, and the year before that, I—

Jennifer I love *My So-Called Life*.

Kate Oh, it's just the best show ever. The year before that, I was watching *90210*. There was always a movie in my room.

[Looking at photo]

Kate We were watching *Six Feet Under*. We were watching the finale actually, and that's when you came in. You had never seen the show before and by the end of that finale we were all in tears. I think it was cathartic in a way considering how awful our own finale was.

Jennifer It was so well done, *Six Feet Under*.

Kate It was so well thought out, and there was such consideration in it.
[Looking at the photo]

Jennifer That was when they were going to kiss.

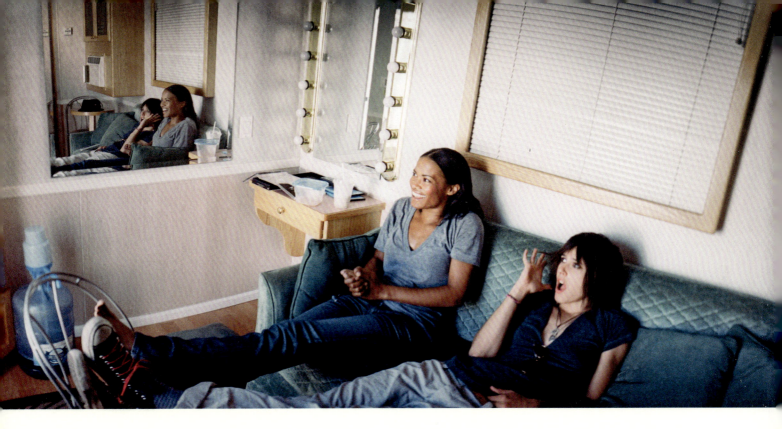

Kate Who?

Jennifer The brother and sister were about to kiss.

Kate What brother and sister?

Jennifer On *Six Feet Under*. Right? Am I right?

Kate No.

Jennifer Yes.

Kate Uh-uh. [Looks at photo.] What pants am I wearing? Oh yeah.

Jennifer Yeah, this is where you guys are cringing because they're sitting—wait, wait, wait—the woman is sitting on the bed, and the brother comes up from behind her.

Kate [gasps] Right. My God, look—we're all into it! This is Rose's trailer. Rose is my perfect movie companion. ■

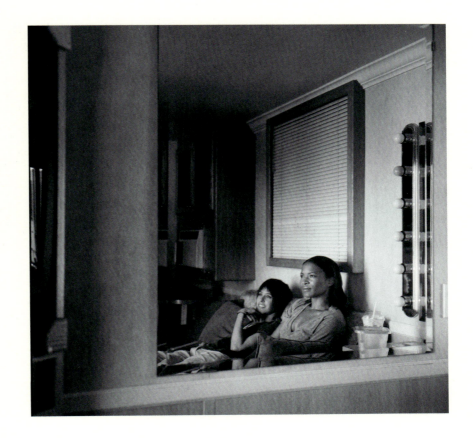

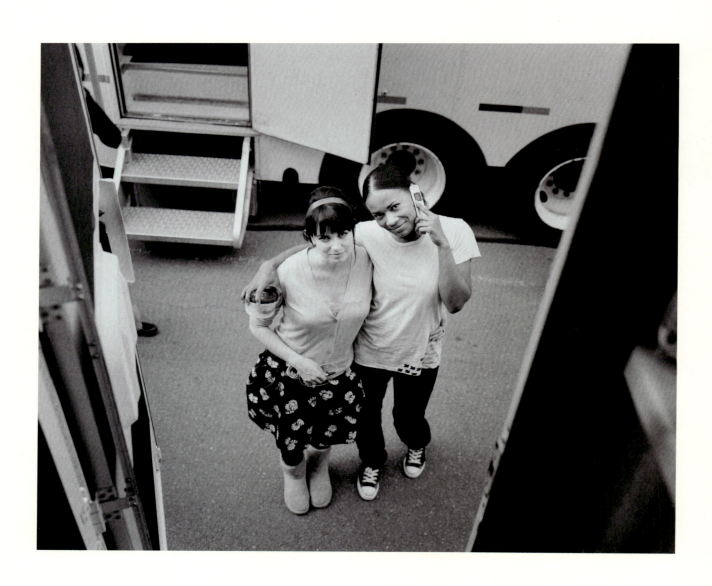

Mia [Looking at photo] Oh my God. Aww. Rose and I. Can I just say about Rose—that was one of the most surprising friendships in my life that I've ever had. Like, who knew that this woman would become one of my best friends?

Jennifer Didn't you ask her to help you move in or out when she first got to the show? You were moving and you know how when you moved, you always recruited somebody?

Mia Yep. Were you recruited ever?

Leisha I was your husband for like two years.

Mia You were my husband?

Jennifer Yes, she was.

Mia You were? Were you fixing things?

Leisha Everything. I fixed things. I did things. I ran errands. I kept a happy home.

Mia I loved living with you for two years.

Leisha I loved living with you too.

Mia But Rose and I like, I don't know, you know? I met her and then we just—I think we bonded over the fact that we couldn't swim, and the only time I've been in a pool in Vancouver, except for the triathlon stuff, was with a set in place, and I went swimming with Rose or nonswimming with Rose, and then she just became this great woman in my life. Like, we talk on the phone every day and she knows everything about me and she's a wonderful friend. And she's come from a tough background, and because of that, has become a remarkable person and somebody to look up to and admire in terms of who she is today. Sorry.

Jennifer No, that's okay, get it down.

Mia I want it to be there.

Jennifer No. It should be.

Mia I want people to know how wonderful Rose is ∎

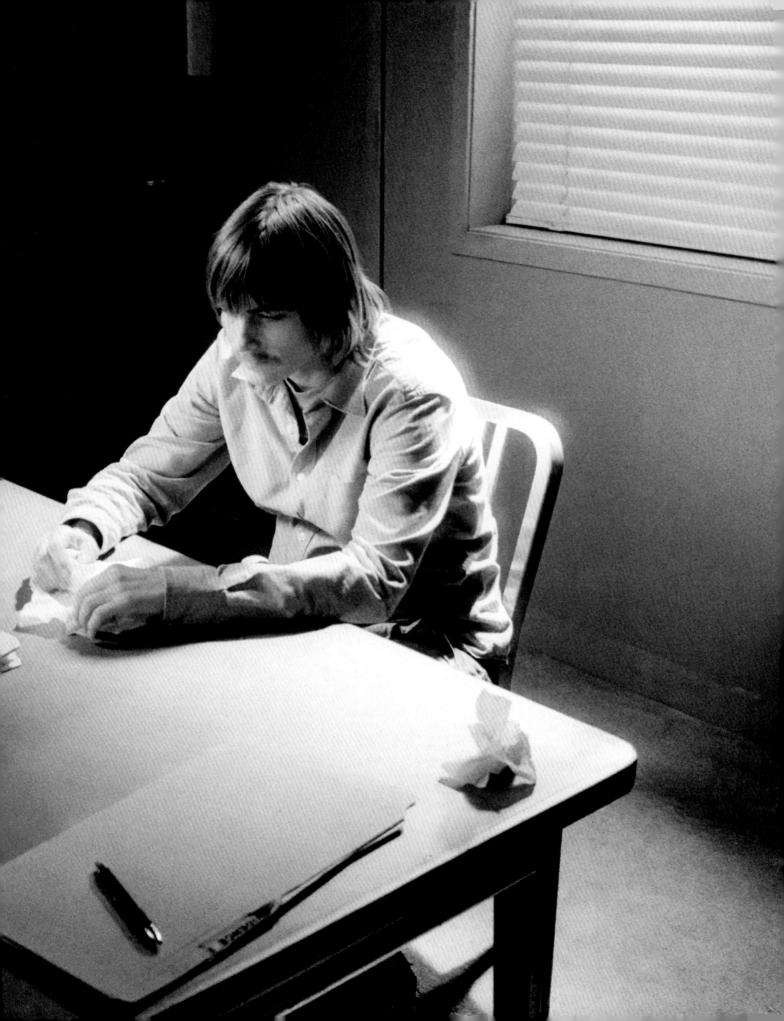

ILENE, DANIEL, ALEX AT V-DAY

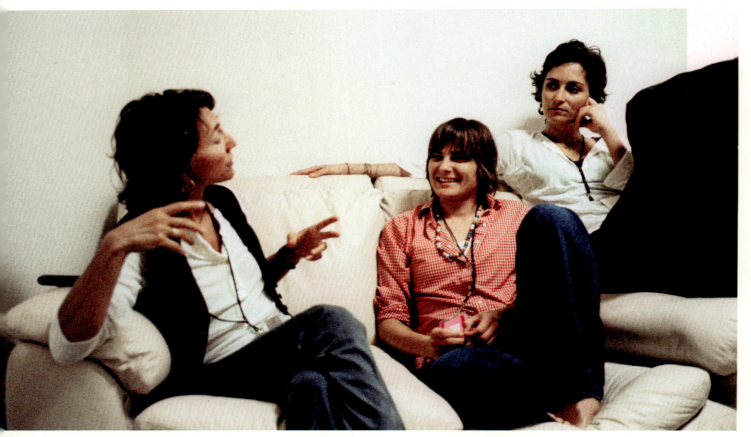

Daniel Coming into this particular group was challenging. I was the only new character who had joined that season, and group dynamics can be difficult. But luckily I had people I could talk with, and I had support from some of the cast because when they noticed some things going on they reached out and let me know that it wasn't personal. So I felt relatively cared for at first, and then things took an unfortunate turn and I never really understood . . . group dynamics are a pretty tricky thing. It's risky to inhabit the role of an outsider. Once, when talking with this Shakespearian actor friend of mine, he told me that in his experience it sometimes happens within a troupe that if they're doing a long run of a play and somebody's playing the villain, they might be treated as the villain offstage as well. So I kind of wondered if this type of dynamic was at play at all. It was challenging to my feminist sensibilities, seeing this behavior coming from women. It was only a couple of people who spearheaded that dynamic, from what I could see.

Jennifer I felt like, when we were away from the set, that wasn't the case. When we were in New Orleans, it was a different scenario.

Daniel That's true.

Jennifer What was your experience going to New Orleans for V-Day?

Daniel It was amazing. I underestimated the weight television has in the culture—I didn't realize how powerful it could be. Since being on the show, I've met all types of men and women who watch the show and are deeply moved by it and also feel validated by it. It's quite amazing. From factory workers to heads of corporations, journalists and health care workers. It's quite something, how TV reaches people all over the world and across a lot of the social spectrum.

But talking about V-Day, I've been lucky enough to be part of one aspect of the feminist movement which is V-Day. Being in New Orleans was life-changing for me. On the one hand, it was amazing to work with you and Alex [Hedison] and Ilene, and all these amazing actors and artists, but what really blew my mind was meeting activists who've come from all over the world, including right there in New Orleans, who work hard and are risking their lives all the time to make the world a better place. Basically, it was humbling, and I questioned, "Why am I here?

How does what I do compare to what these people do every day?" Maybe everybody felt that way a little bit, but to be able to be part of the dialogue about changing how women and girls are treated in this world was really moving to me. And, on a personal level, it gave me the opportunity to ask myself what does it mean to be a woman in the world. It's powerful to be in the same space as thousands of amazing people with a common cause. And it was great to be on the show—it was a golden opportunity to be part of telling a story that is rarely told in the mainstream. And, as an actor, it was a challenging opportunity to make many transformations, and investigate different sides of this character. It was a blessing, really. I'm happy to be a part of it.

Jennifer For me I think being at V-Day was a culmination of the work we had done on *The L Word* and the work we had done as individual women. Meeting all these other actors who were all unified by virtue of their desire to tell the truth, to live the truth as best they could, and to support one another as we all try to help one another out of the boiling pot was inspiring. We were unified in our desire to become more conscious. It was just an extraordinary experience for me, too. It was a very clear collective effort to use acting as a way to bring storytelling and activism together ■

Rachel I had a dream set in the corridor of the hospital where Dana died—a location I never went to. But I was really fiercely affected by Leisha's last scene there, the one where she's told Dana has died. She slumps down the wall, that mechanical flower starts to dance and sing "You are my sunshine." Anyway, I'm working there as a receptionist, and some overly friendly woman sidles up to me, asking weird questions, rubbing elbows with me. To my mind she looks and acts the complete opposite of myself in character. As soon as she's rubbed elbows with me, she walks away, now transformed. She has sucked all my personality out of me, and adopted it for herself, and leaving me with her characteristics. Suddenly I'm totally negative, foul-mouthed, rude, and sneering. Then an Alice-in-Wonderland girl walks in with flowers and a balloon, and suddenly Alice (not Leisha) is there. Alice-in-Wonderland gives Alice the balloons, rubs elbows with her. I ask Alice from behind the glass of the receptionist desk, "Did she take your personality?" and Alice replies, "I think she did, because I just lost all my confidence. I feel really inferior right now." ∎

Laurel I dreamed Ilene gave me a script where we were all naked in the Planet for an entire episode. I woke up in a panic attack sweating. In the dream she was very determined ■

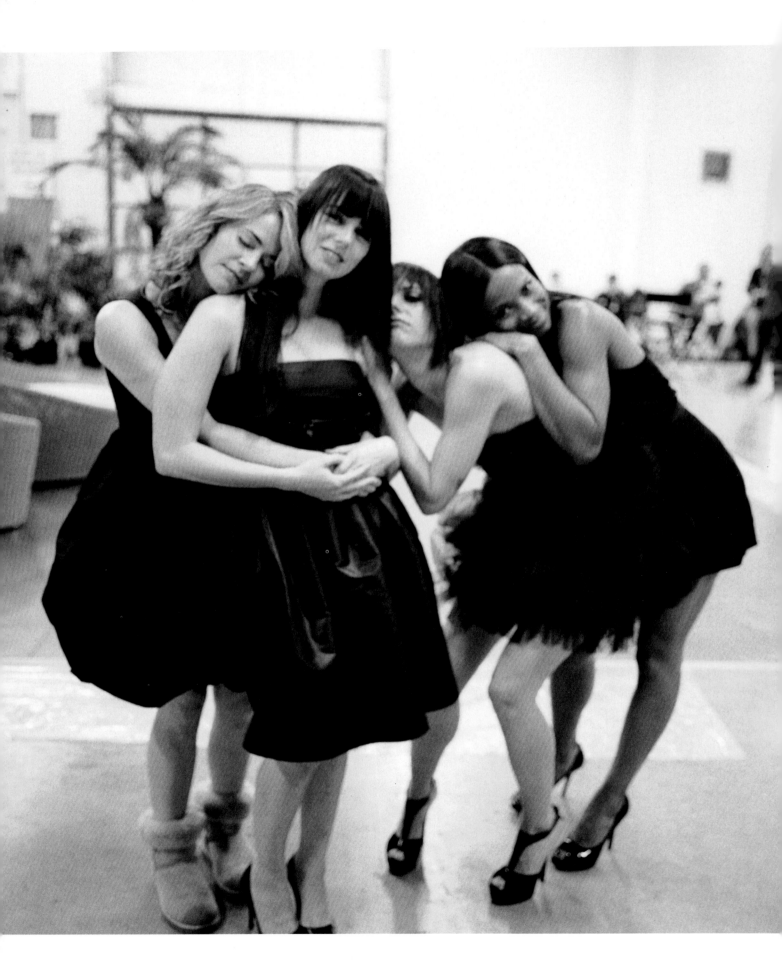

Rose It was definitely my best, most fulfilling acting experience so far, for sure. It was just a great experience. So many times acting is not just about acting. It's so technical. For me personally, it always threw me out of just being connected because it's so technical. I guess being on the show taught me how to act and—

Jennifer Fulfill your technical requirements.

Rose Exactly. So I just feel a lot more confident, but I definitely feel like I'm starting over at the same time.

Jennifer In what way?

Rose In every way, trying to move forward my career. I definitely feel that I'm starting over ∎

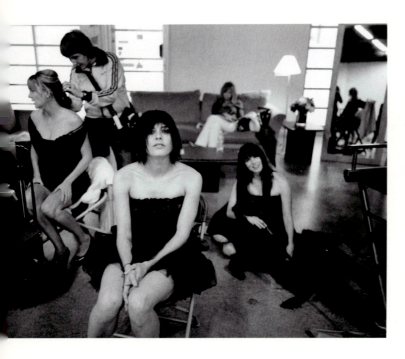

Jennifer Now, why did you wear a dress?

Kate Because Cynthia said, "Why don't you shake it up a little bit? It's the finale, and everyone's expecting you to look one way; let's just do the opposite." She was right. She said there would probably be some backlash and people will hate it, but so what. It shows a different side and it's more interesting then another shirtless vest look. I couldn't have agreed more. Gotta love Cynthia.

Jennifer Were you glad that you did it?

Kate Totally. It wasn't some major thing, but I thought on this show, yeah, I thought it was great ∎

SIXTH SEASON POSTER SHOOT

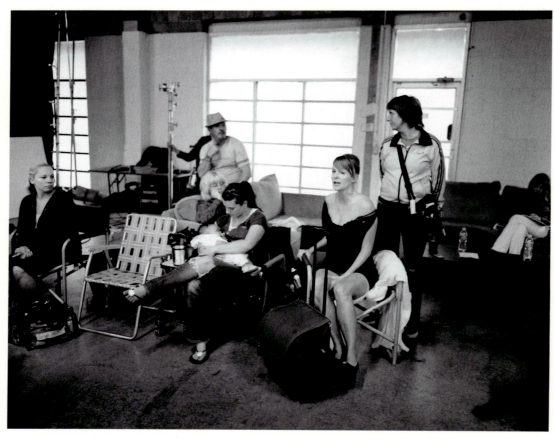

Jennifer Are you competitive at all, would you say?

Rose Absolutely.

Jennifer You are so much fun to watch play tennis. Hysterical. You get really serious. I can get competitive, but I remember not wanting to really play too hard because I had the triathlon coming up, and I thought if I injure myself in this game, I'm gonna be so mad.

Rose Those were fun times. And then when Matthew [Rachel's partner] would come up, he would always get everyone riled up to play.

Jennifer Is he competitive?

Rose He's competitive, too. He would get mad. The girl would beat him and he'd just start to hit those mean ones, like really hard ones that you don't even dare try to hit back because—

Jennifer You know it'll take your arm off. And John [Stockwell, one of our beloved directors] could be like that, too. I remember he was pretty easy on me because I hadn't played tennis since I was twelve, basically, and then on a fluke I hit it past him and then he showed me no mercy ∎

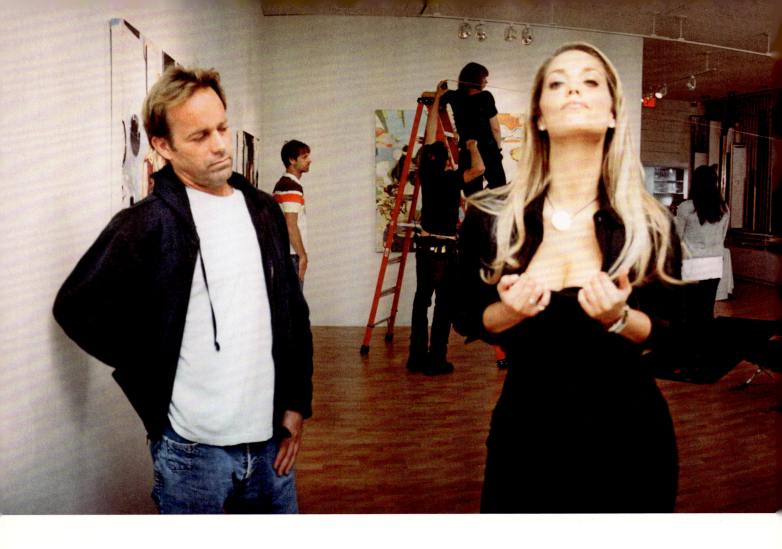

OLIVIA WINDBIEL

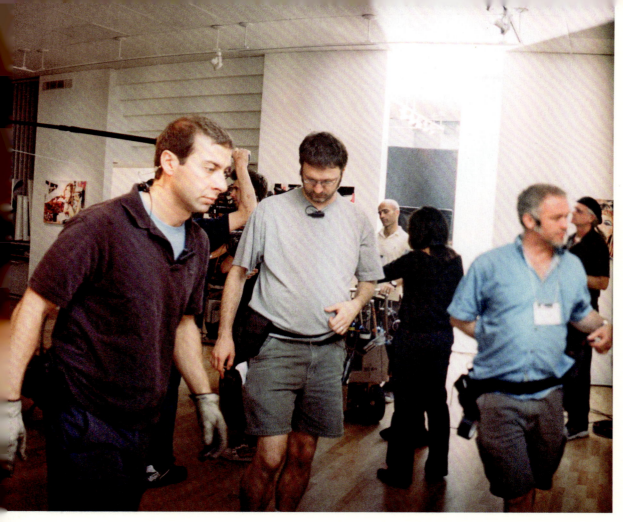

JOHN STOCKWELL, ELIZABETH BERKLEY ON SET

PRESTON COOK

JON WOLFE NELSON

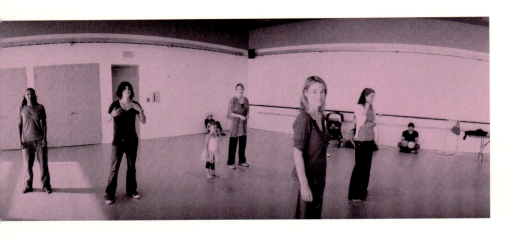
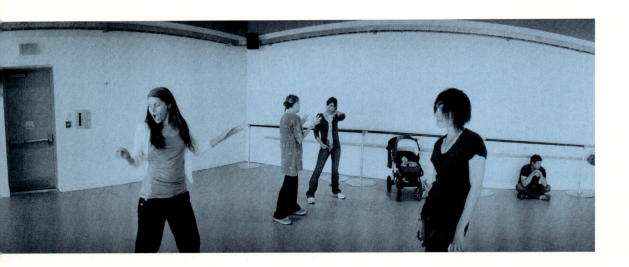
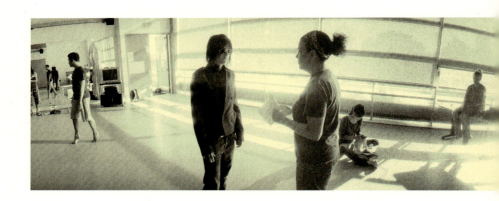

Jennifer I loved doing [episode] 607.

Kate I did too. I had a blast.

Jennifer For me, it was so much fun because I could watch everybody else do their work and watch them do stuff that they don't normally do. You know what I mean? People are pushed out of their comfort zone, and you admire them and sometimes you just have to laugh.

Kate Yeah, and we were all together too. Being on location with everyone was always so much fun. I always go back to the lack of ego we all had. I mean, even though we all had our own insecurities, at the end of the day . . .

Jennifer How was the dance rehearsal?

Kate That was fun that day. Yeah, this wasn't so bad because everyone brought their kids. It was like a field trip.

Jennifer Also the space—to be in that space is really nice.

Kate And our teachers were awesome too.

Jennifer They were really sweet ■

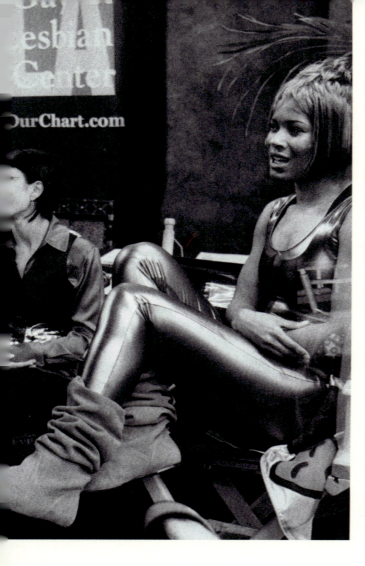

Jennifer How often did you guys practice?

Rose Not much. I think we practiced probably around, just for a week, probably like four times.

Jennifer But I think that's probably more than everybody else. For you that's not a lot. I remember you practiced in the lobby, or in the hallway. I also remember that Rose [Troche] didn't want us to show each other our dances. Do you remember that?

Rose Oh, why? No.

Jennifer To set up this kind of fake competition.

Rose Oh, really?

Jennifer But then, when you guys were practicing out in the hallway, I think she underestimated how much everybody would root for one another.

Rose Yes exactly, exactly.

Jennifer Because I really wanted to learn your guys' dance.

Rose Everyone was really good ■

Jennifer How did your rehearsals go for episode 607? Did you guys have fun?

Leisha Oh, we had the best time ever. For our little hip-hop thing?

Jennifer Yeah, yeah.

Leisha We had a blast. We felt really cocky, and we practiced and practiced. Rose really drove us into the ground—that's when she got super-competitive. "We're gonna win this!" She made us do it over and over. In every nook and cranny of the set we were having secret rehearsals.

Jennifer You guys would practice in that little lobby in the office.

Leisha Yep. And in the back, on the day. In the parking lot, on the other set.

Jennifer She did?

Leisha Oh, she made us do it one hundred times.

Jennifer No way. That's her aerobics experience. [laughs]

Mia She was amazing ■

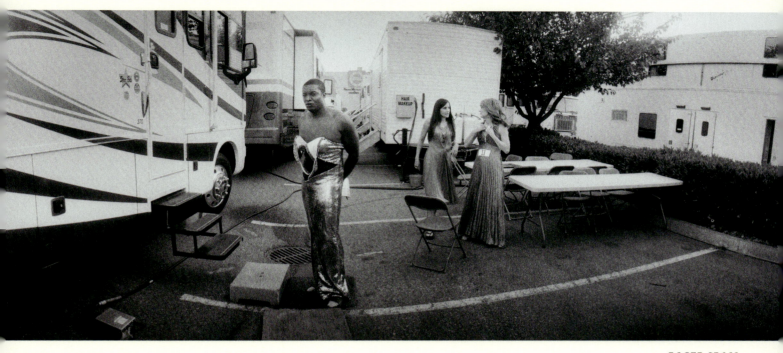

ROGER CROSS

ALEX HEDISON

MEI MELANÇON

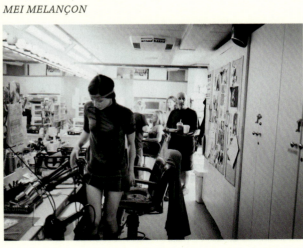

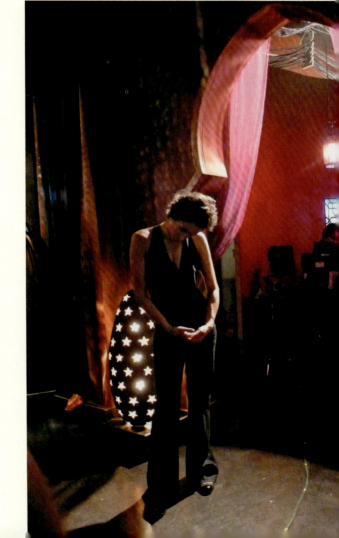

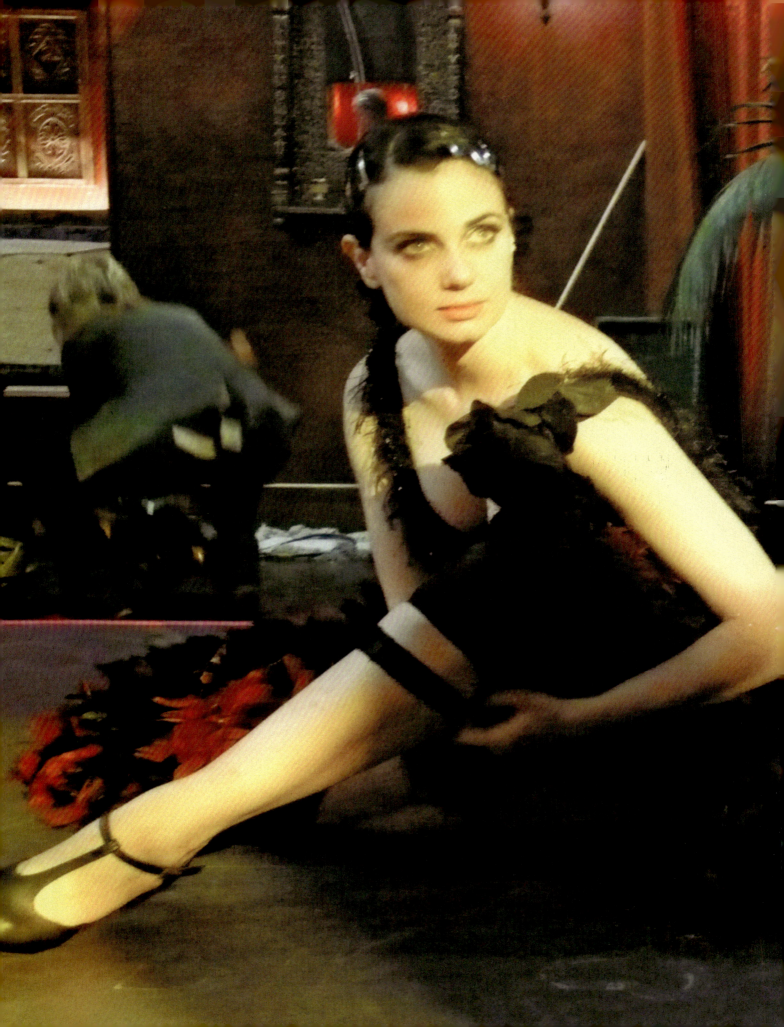

Laurel [Director] Rose Troche had so much enthusiasm. She would come into hair and makeup and go over where she thought your character was before every scene. She was so great about finding the truth in a situation or a scene. She fought hard to keep the show authentic and real. I admired her so much for that. When she directed the dance episode in season six, she cried so hard when it ended.

That's when it hit me it was over, and her vulnerability made me realize we had been given this great gift, and she was a huge part of it. She was such a part of its success. Also, she was like a little girl with sex scenes. She would get really embarrassed. By the end, we were just like, "Hey, let's do it this way." I felt very safe with her. She just knew and loved these characters so much.

Rachel I love Rose Troche. She's generous, hard-working, committed, knows her characters and storylines inside out. She brings ideas and questions that challenge you as an actress, pushes you to go that little bit further. She's a scream to play tennis with and makes me laugh. She's a powerhouse.

Mia She is an excellent, thoughtful director, with a heart as big as a house.

Kate Rose could say "Hello" to you and you would be on the floor in hysterics. Also, she was so dedicated to the show and all the characters. I always wanted to make Rose proud and give it my all when she was around. She deserved it. She was our original chief ∎

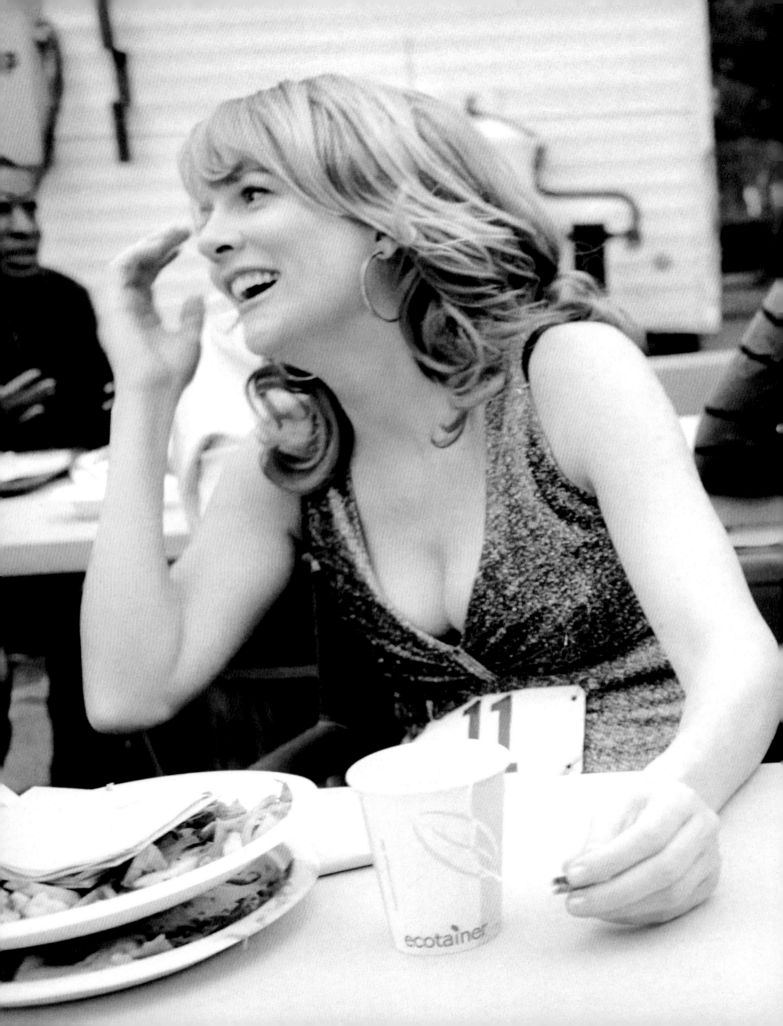

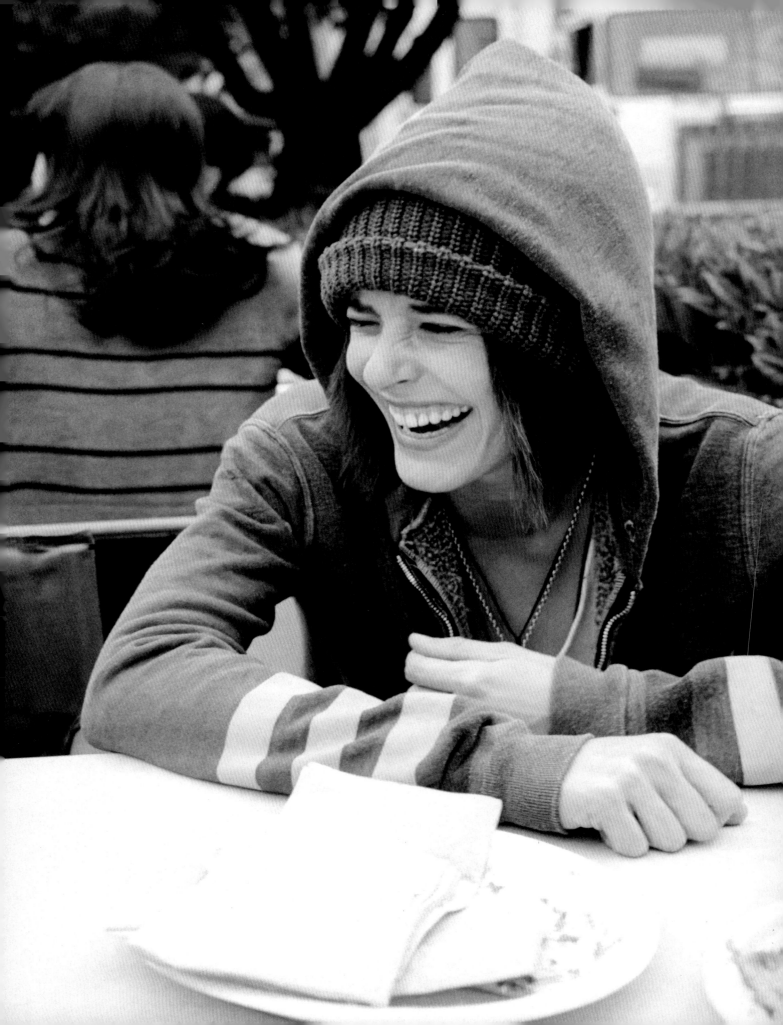

Kate [Looking at photo] We just had the fucking best time together. Nobody had any bullshit egos. I'm sorry, you don't sit all together like this normally.

Jennifer No, but this was also episode 607, the penultimate episode, where you kind of can't get enough of each other in a way, and it's also a pleasant episode.

Kate But we did this fifth season too. We had that picnic table. Seriously, I'd be lucky to have something even remotely close to this experience again. We all just loved each other, even during the bad times. I mean, we were friends—that was the beauty of this show is that we were all genuinely friends.

Jennifer And then that played out in the show. Like whenever we had those scenes where everybody was together, it made it so much easier.

Kate You just can't fake that chemistry. Sometimes bad chemistry will work well onscreen, but that was few and far between on this show. It's not every job where you feel like work is an extension of playtime. Where you can spend your days laughing in between takes. We all had our quirks but they meshed together perfectly ■

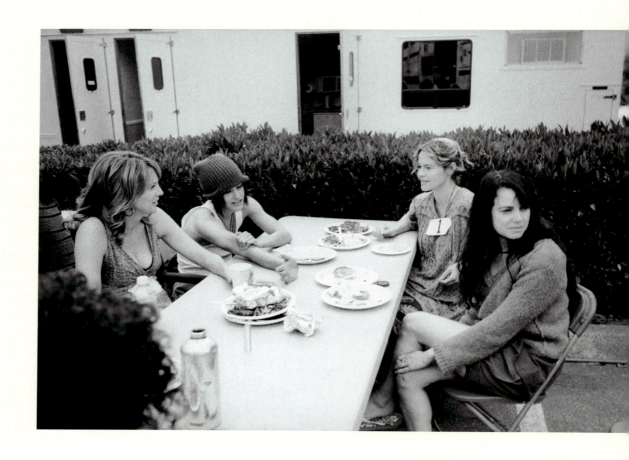

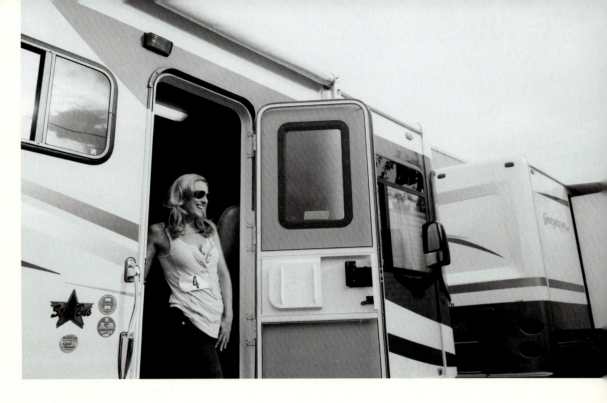

Marlee It's like sometimes I'll go to this small little town in the middle of nowhere and I'm speaking to a group of general people, and two women come up and say, "We love *The L Word*. Thank you." And they say thank you because they have no place else to go, except the show. And you can see genuinely that they really feel grateful. So I stand up and give them a hug.

That's the part of the show . . . I see that sort of thing so many times. When women come up to me, or there will be a group of people, like a group of Jewish women, you know, and they're all proper with their little Lion of Judah pins, and one woman will come up and she'll go, "I'm a fan of *The L Word*." And she'll look for a second. And she's saying something to me by saying that. And it touches me by just watching these people who almost whisper, "I'm a fan of *The L Word*," and they'll just walk away.

Jennifer Right. Because they're talking in code. And that's really moving for someone to feel so hidden, to feel like they have to hide who they are, who can be recognized in some way, if even by someone who is ostensibly a stranger.

Marlee She couldn't say it freely. And that's the part—I had an experience of prejudice, hard, hard, full-on prejudice against gay people, because I was asked . . . you know I've been speaking a lot on the circuit, and have done so for the last eighteen years, and I was invited to go to this—oh, I'm gonna say it—to this thing that was sponsored by a religious group.

Jennifer Ohhhh.

Marlee So I was like, "Great, this is something new. This is a new group." I've spoken to a variety of groups: Jewish groups, teachers, corporations, whatever it is, in a motivational capacity, so I said great. I got the contract, and the next thing I knew, my agent warned me and said it's not going to happen. And I said, "Why not?" It was already a firm offer. It turned out that the people who had asked me to speak were fans of my work, but the sponsors, who were part of the religious group, found out who I am and what I've done in terms of the TV show I did, and then they pulled out their sponsorship.

Jennifer [gasps]

Marlee Only because I did *The L Word*. And I felt a deep sense of compassion for people to whom that happens every day. I mean, I don't want to criticize their beliefs, but at the same time I thought, "You know what? I got a taste of what this prejudice is, that's out there." ∎

Project	**The L Word 601 Free TV**	**ADR Cue Sheet**
Title	**Long Night's Journey Into Day**	Date 1/22/2009
Version	Free TV	Line Count **2**

Character	**Bette**	Phyllis can be such an <u>asshole</u>. (so cruel) *No she had*
Loop #	**028**	
T/C IN	**01:16:47:00**	
T/C OUT		
Reason		Take # 01 02 03 04 05 06 07 08 09 10

freakin

Character	**Bette**	She was born in this <u>fucking</u> hospital and both our names are on the <u>fucking</u> birth cert. so why don't you just give us a break...... and get our daughter in to see a doctor! (freaking)
Loop #	**021**	
T/C IN	**01:28:35:11**	
T/C OUT		
Reason		Take # 01 02 03 04 05 06 07 08 09 10

END Total pages 1

She was born in this freakin hospital and both ~~so~~ our names are on the freakin ~~birth~~ birth certificate so why don't you just give us a ~~freakin~~ break ... you bureaucratic maggot and get our daughter in to see a doctor

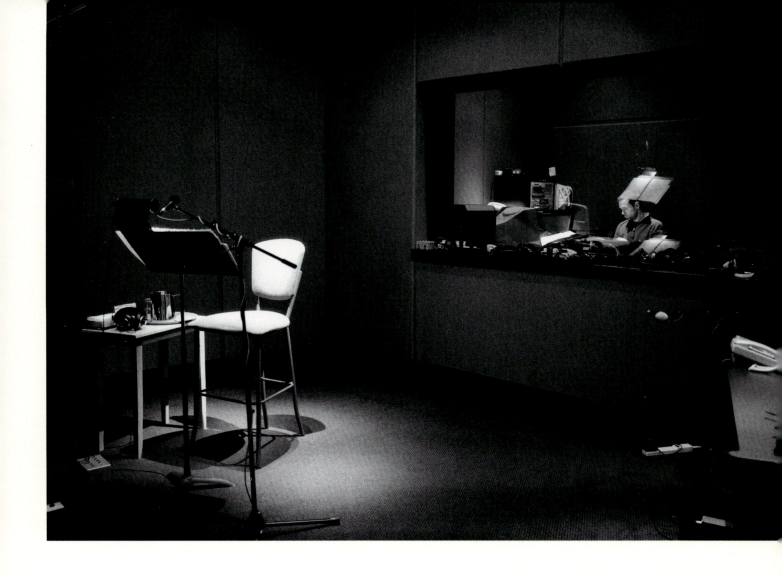

Kate I can't stand ADR [additional dialogue recording].

Jennifer Really? I love it.

Kate Oh, I want to kill myself in ADR.

Jennifer I love it because you can actually make some things better. I like the precision of it. Letting go within the precision. Fun ∎

THE LAST READ-THROUGH

Jennifer How was the last read-through for you?

Rachel It was kind of surreal being at the last read-through. Everyone was aware of this being the last ever, and yet it just went ahead as always. There was no fanfare. I wasn't really listening to the words; I was watching everyone. The last line was read and the response was pretty muted. Everyone was catching everyone else's eyes, and communicating that they felt weird too, but no one SAID it.

Then suddenly it was over. It was almost an anticlimax.

Laurel The last read-through felt very heavy and sad for me. I was in denial about how sad I was until the end.

ILENE, ROSE LAM [PRODUCER], KIM STEER [LINE PRODUCER], LAUREL

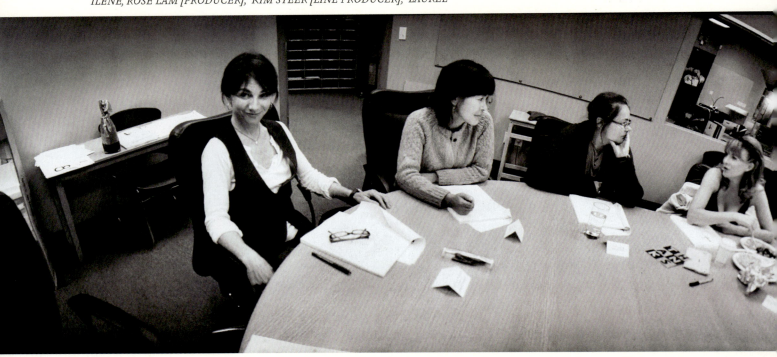

Mia Sad, grateful that I had a job for so many years, confused at what had happened to Jenny, and very disappointed at the way the show transpired over the last season. I felt that the note in which the show ended betrayed the very spirit in which the show was made. The show took a group of women, with the central theme of love being explored over the years. The final season was about murder and mistrust among friends. It felt untrue to the central theme of the show.

Kate Oh, I hated the last read-through. It was so awkward.

Jennifer So when you first went into the last read-through, what did you think?

Kate I was numb. It was awkward and I couldn't feel a thing. I knew intellectually that this was the last one, but emotionally I shut down. Too much all at once. They brought champagne out and it just felt too real ■

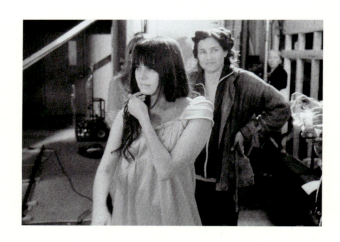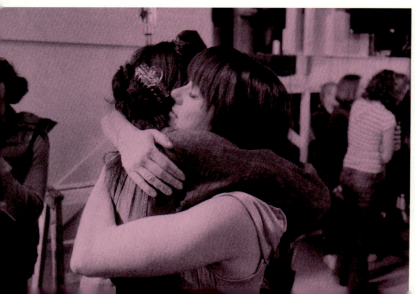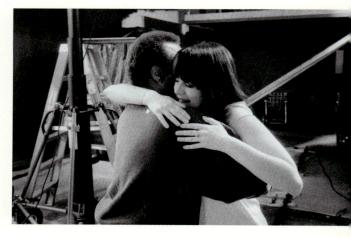

Kate [Looking at photos] This was the last day of work. I remember Mia was about to wrap any second. That's when it hit me, because she was the first to go. I was excited to get out of there because I had exciting things back at home, but to know this was the last time I was gonna have this amazing thing in my life was just horrendous.

Jennifer When she walked down that runway, it almost felt to me like a gangplank in a way.

Kate It did.

Jennifer It felt like a gangplank and a diving board, like she was going to be the first one to dive into the uncharted waters.

Kate Totally.

[Looking at photo] Is this Mia saying good-bye? This was awful. I hated this moment. When I said good-bye to everyone, some people gave some really nice, eloquent speeches, and I knew I wouldn't be able to get through three words if I did it.

Jennifer I spoke to everybody, and I was really glad. I felt like a horse running home to the barn. I felt excited in a way to start something new, and extremely proud of everyone.

Kate I just told Alysse [our first assistant director], to tell me when my last shot was. I wanted to go around and say good-bye personally to the crew one by one. When she said, "This is it," I had such a sinking feeling. So I started to go around to the crew one by one, and each one was harder and harder. By the time I got to Jules, the last one, we were both a mess.

Jennifer You lost it.

Kate Oh, I lost it.

Jennifer Well it's gotta come out sometime.

Kate Oh God, it was awful, but yeah. And I ran away. I was like, "I'm out. I'm gone."

Jennifer It was also so awkward to be shooting your last scene with actors you didn't really know. And how hard for them.

Kate That's what I hated. I didn't like finishing that way. But it was a blessing because it would have been an emotional overload had any of you been there.

Rose That was when it finally hit me, I think, when Mia finished. It was like, "Wow, this is it." It's like you know this is coming but now that it's here, wow.

Jennifer How did you feel that you would handle it? I know you were on the show for three years, right?

Rose I felt very lonely around that time, for some reason. Not necessarily that I was, but there was just something in the air. I was just kinda going through my own thing, just departing on a solemn note. I wanted to come home and be with my friends.

Jennifer Right, have something solid. It was like the ground is moving, and you know pretty soon it's not going to be there anymore.

Rose I think by the time I had left, some people had already left, too, which also made it feel different.

Jennifer Who had been wrapped by then? I think Kate?

Rose Kate was wrapped. I think Leisha was wrapped, too. Laurel. So people were gone. It was just you, me, and Kate French. I think we were the only ones.

Jennifer And Rachel. I remember originally on the schedule they had you wrapping last. >>

<< *Rose* Yeah. Which I didn't understand.

Jennifer I said to them, "Don't make Rose wrap last. That's not a nice thing to do because she's only been here three years." I said, "Let me be the last one."

Rose Which I think is far more appropriate.

Jennifer I thought it would be easier for me because I'd been there longer. And also, frankly, for me there was part of me that was very excited, very ready to just let go. We were not telling stories in the way that we used to. Not that everything has to stay the same, because things change, but it was getting harder for me to sustain the story.

Rose Exactly. And didn't you feel that you owed it to your character, in a way? Like you just felt like you're letting your character down.

Jennifer And to be honest, I like change. I get excited when I feel the ground moving ∎

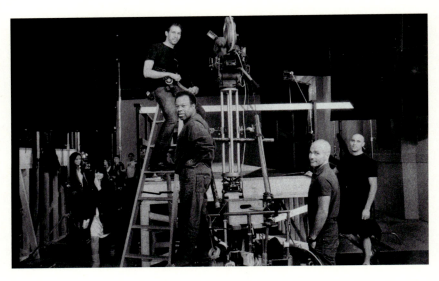

Jennifer After the show wrapped there was a lovely, surreal party in the studio. Rachel and I were the only main cast members there. I was very excited to be finishing, but at a loss as to how to disentangle myself from this PLACE, from the people I had grown to love—not that I wouldn't continue to love them, but I needed to move on. This was a place, a process that had introduced me to myself, to a whole other community, to another city, to another more complex, more integrated way of looking at the world and my place in it. Where could I go to have my own safe jumping-off space? Certainly it was not on that runway where we shot the final credits, and it wasn't after the interrogation scene, the final scene that I shot. My trailer? No. The office? No. It was the camera truck, with the boys from the camera department. My last moments on *The L Word* were spent on the camera truck, drinking rum, deconstructing everything that had happened over the last six years with the men who had made me laugh and think. These were the men who had always made me feel safe. They were the ones who had provided a balance to all the estrogen, as lovely as it was. Thank you, gentlemen ∎

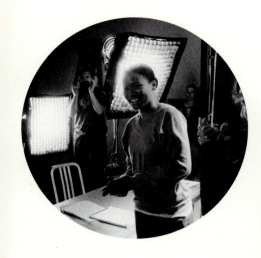

Leisha I don't remember the last season, really. I think I blanked it out.

Jennifer Yeah, but the whole thing of trying to set one of us up as a murderer just felt like I held that lie in for so long.

Mia Can I just go on the record for saying something? I don't care if Jenny lived or died. It was the point that they took a show that people really liked and was meaningful and sold it out, and I felt like the whole—everything that we collectively created together over these seasons was discarded because we need to have a prison element in this pilot so we need to introduce murder, and it was just incredibly disappointing. On the whole, it was a really wonderful, wonderful experience, and it was so sad not to have been told the truth.

Jennifer It was so fractured at the end.

Leisha Yeah. I feel like it just didn't make sense, and nobody had anything to grab onto. The point is, we still don't know who the murderer is.

Mia Oh, right. Is Jenny dead or . . . ?

Jennifer I don't think they knew.

Leisha I like how you guys are asking me like I know.

[laughter]

Mia Did you get answers in the pilot?

Leisha People ask me all the time.

Mia I think that the way in which the last season was handled was very, in many ways, disrespectful to—

Leisha —the characters.

Mia At a time when Prop 8 was being put forward, and people were voting on it, we didn't need to end with a season about hate.

Jennifer Right, right, right. I think having now gone into the workplace beyond this show, you know, most places don't feel that they owe you anything.

Mia I know.

Jennifer The fact that we had the kind of dialogue that we did have—it's just unprecedented.

Leisha We were the luckiest people to be on that show. The luckiest actors. We experienced something we will never forget and we were part of something very, very special. Not only to us, but many people. I feel grateful.

Mia It was a dream job. In retrospect, it was a dream job.

Jennifer I think we got really accustomed to being able to be heard thoroughly and frequently. We were used to being given all kinds of information.

Leisha I think you're absolutely right. >>

L Word Season VI Productions Inc.

Executive Producer: Ilene Chaiken
Executive Producer: Rose Lam
Producer: Kim Steer
Production Manager: Christina Toy
Director: Ilene Chaiken S/D

Set cell:

EPISODES #608 "LAST WORD"
608 Latest Shoot Schedule: WHITE: 09/19/08
608 Latest One-Liner: PINK: 09/19/08
608 Latest Script: Full Goldenrod: 09/18/08
1st Revised Pink Revisions: 09/30/08

Nearest Hospital

PRIVATE BLOCKING W/ ILENE, BOB & CAST @0715

OPEN BLOCKING @ CALL
SAFETY MEETING ON SET AT CALL

DATE: Monday October 6 2008
DAY: 11 Of 11

CREW CALL @: 0730
SHOOTING CALL @: 0800
LUNCH @: 1330
Grip/Elec @: N/A
Props/Camera @: 0700

SUNRISE: 0720 SUNSET: 1839
WEATHER: Light Rain
Hi: 12 Lo: 10 POP: 80 %

SCENE	SET DESCRIPTION	D/N	PGS	CAST	LOCATION
	BLOCK SHOOT NIKKI, TASHA & MAX				
35,78A	**INT INTERROGATION ROOM** Nikki is interrogated	N2	1 5/8	11,14,23	Stage #3
77	**INT INTERROGATION ROOM** Tasha is interrogated	N2	3/8	8,14,23	
11,36	**INT INTERROGATION ROOM** Max is interrogated	N2	2 0/8	9,14,23	
	BLOCK SHOOT HELENA & BETTE				
15,17,29,78	**INT INTERROGATION ROOM** Helena is interrogated	N2	2 0/8	7,14,23	Crew Park is in the lot Across from Stage #3
23,43A,73	**INT INTERROGATION ROOM** Bette is interrogated	N2	1 7/8	1,14,23	

LAST DAY CALL SHEET

<< *Jennifer* So that once you get to the kind of situation that happened sixth season, it's so extreme the other way that you felt there was no recourse. It's already done. It was extremely hard, and I didn't know how hard it was because I really kept it all together all season long. I was very, very much about business—get your work done—until the day I saw that lineup for the poster photo shoot. I remember arriving to work and Mia said, "Have you seen the backdrop?" I said, "No," and walked to the set. On the set there was a mock-up of a police lineup. First I thought, "Oh, okay," but then when I actually imagined being Bette walking up to the lineup, I became so furious. It felt like such a lie, and it felt like selling the whole gay community down the river, and characterizing them the way that they've been characterized for so long in terms of film and television—it's, oh you know, you're >>

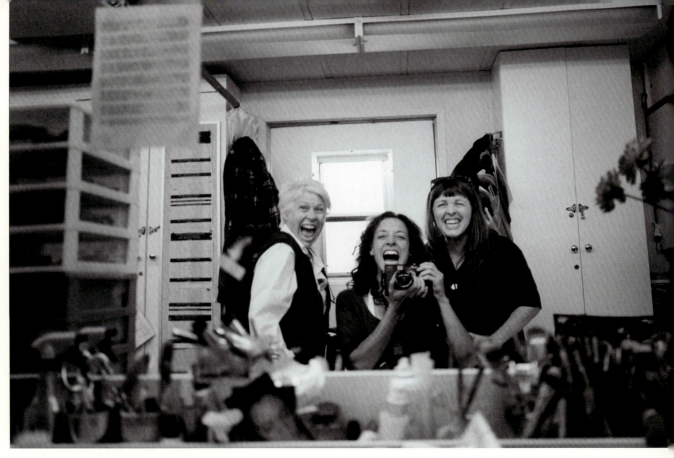

JOANN, CYNTHIA SUMMERS, AND ME, MAKEUP TRAILER

<< the mass murderer or being "other" means that you're going to be a deviant in a very negative, uncreative way. I went back to the hair and makeup trailer. I just was so furious. I don't think I've been that furious—certainly not at work. But it was cathartic. Ilene and Howard [from the Showtime advertising department] were both gems that day. Really generous—I think they knew it was about more than just the concept . . . I think there's a picture documenting it in here somewhere.

Leisha What? Who took a picture?

Jennifer I did.

Mia You look like you're laughing.

Jennifer Well, it becomes hysterically funny, because you realize you've acted—you've let out absolutely every aspect of your shadow's side in such an intense way, and then it flips over to the other side, and it's just absurdly funny. And I said, "Okay, we've got to document this time. On the count of three, I want everybody to scream." We were laughing at the same time. It's good to get it out. I like that picture.

I guess we all had our processing sixth-season moments. It was such a crappy way to end a show that had started out being about love and friendship. But what we took with us—our friendships, the things we learned—those stories will keep on going ∎

FINAL PRESS AND 2009 TCA PANEL, LOS ANGELES

BELOVED HOWARD

Pam The L Word reflected so much to me from the universe. I was guided to learn and grow a bigger and warmer heart beyond measure. Being in *The L World* (my description) was to learn about others, to not embrace rumor, myth, and judgment, but to live and breathe with others ■

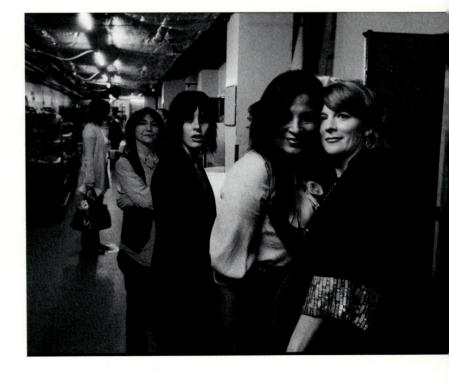

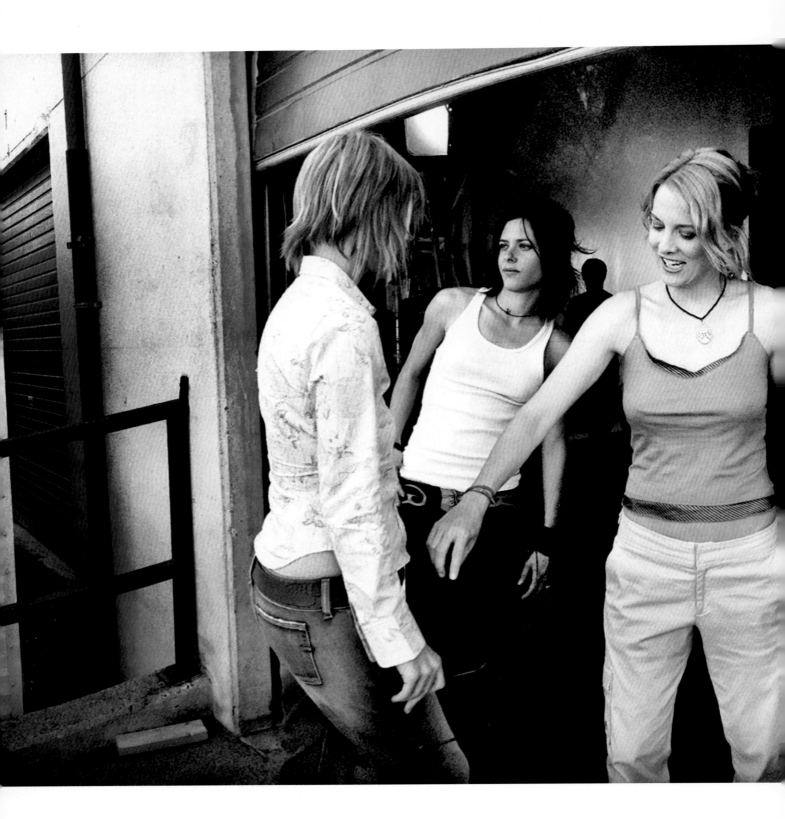

Rose I just thought it was a great experience, and just working with so many women was just very positive. I learned a lot from everyone. It was a better experience than I could've ever anticipated. I have some friendships from this experience. It changed my life, because it was actually the first time I was able to support myself as an actor, which is huge for me. I've always had side things here and there. Overall it was one of the best experiences of my life, even though there were some frustrating times. It definitely has been a big part of my life.

Jennifer What did you learn from Leisha?

Rose I learned how to not take myself seriously so much, sometimes. I learned to just let things go sometimes. She's kind of fearless, in her own way, and I admire that about her. I had like a semi-meltdown for our first sex scene, and she was like, "Come on, let's just go do it! Fuck it." She said, "Would you rather be doing this with a guy, poking you? Let's just go have fun!" I'm like, "You're right." Oh my God, she's great. And she's just so talented. It's kind of mind-blowing how her comedic timing is brilliant.

Jennifer And the versatility, like the scene where Dana dies, she's just so in there. She's not afraid of that.

Rose Yeah, she's a great actress. I really, really enjoyed working with her. She made my job so much easier.

Jennifer And what did you learn from Mia?

Rose Patience. I definitely wouldn't have necessarily thought, out of everyone, that I'd be the closest to her, but she has a great heart. And when she's a friend, she's a friend. And we've had our fights, for sure, but I definitely learned how to just deal with a total different dynamic that I'm just not used to. I just admire how much she gives. She can give back in a lot of ways. Like her whole Malawi project, it's just inspiring. And I helped her a little bit with the fundraiser. She didn't really teach me this.

Jennifer Just by example.

Rose Yeah, that it's not all about you all the time. Like, you need a job, boo-hoo. I'm blessed, and there are a lot of people out there who have it a lot worse.

Jennifer And there are ways that we can help them, even if we don't have everything we want for ourselves at any given time.

I'll tell you, for me, I learned so many things from this show. I learned about issues that had been termed "gay issues." At the time, I had never really thought about the gay community. I never really thought about the lesbian community. I'd never thought about them legally, politically, and the first time it dawned on me was when we were preparing for the pilot, sitting with my husband in a restaurant booth, and he turned and kissed me. And I thought, if this were my partner and we were gay, this would be a huge event in this restaurant. It really was an epiphany. It hurt my heart. It spoke to my own sense of otherness. And so learning about the gay community was a really big deal for

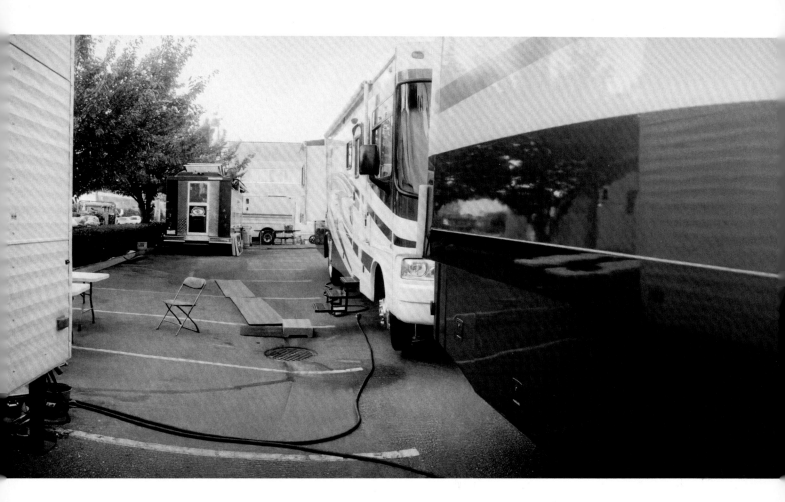

me. Learning how everybody is interconnected and how the gay community is not separate from me was really significant for me. Working with other women was really significant for me. I had never had the opportunity to work with that many women, and as a young woman, I didn't have a lot of female friends. I was always with guys: I had my brothers, and my best friends were boys or men. So to be with women all the time was an adjustment. At first it was hard, because I didn't understand why we were all TALKING for so long [laughs]: Why do we need to TALK about this for so long? Can't we just go DO it? The whole process of talk, talk, talk at first was really frustrating. I've since grown to appreciate it. There was value to talking through things. It connects us. It's really valuable, not only learning who the other person is, but learning how you think or feel about something and creating a bond within a community of people, and learning to respect other people's ideals enough that you allow them the time to say what they need to say. So I think I went from feeling like an individual to being part of a group. And taking responsibility for this small group and then taking responsibility for my character and my place in the world, and trying to do it all through the filter of love. Always love. Like so many other women in the cast, this show has deeply changed my life ■

ACKNOWLEDGMENTS

Thank you Deb Ezer and my entire posse in the Yale Women Writers of Los Angeles for your support and eagle-eyed edits. Thank you to Roger Shaw, Karyn Gerhard, and Kayla Belser of my Weldon Owen family for your guidance and patience. You resurrected this book and made it new again.

weldonowen

an imprint of Insight Editions
P.O. Box 3088
San Rafael, CA 94912
www.weldonowen.com

CEO Raoul Goff
Sr VP Group Publisher Jeff McLaughlin
VP Publisher Roger Shaw
Senior Editor Karyn Gerhard
Assistant Editor Kayla Belser
VP Creative Chrissy Kwasnik
Art Director Megan Sinead Bingham
Production Design Jean Hwang
VP Manufacturing Alix Nicholaeff
Senior Production Manager Joshua Smith
Strategic Production Planner Lina s Palma-Temena

Designed by The Goggles Media Group

© 2025 Jennifer Beals

All rights reserved. No part of this book may be reproduced in any form without written permission from the publisher.

ISBN: 979-8-88674-225-1
Limited Edition ISBN: 979-8-3374-0220-8

Manufactured in China by Insight Editions
10 9 8 7 6 5 4 3 2

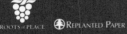

Insight Editions, in association with Roots of Peace, will plant two trees for each tree used in the manufacturing of this book. Roots of Peace is an internationally renowned humanitarian organization dedicated to eradicating land mines worldwide and converting war-torn lands into productive farms and wildlife habitats. Roots of Peace will plant two million fruit and nut trees in Afghanistan and provide farmers there with the skills and support necessary for sustainable land use.

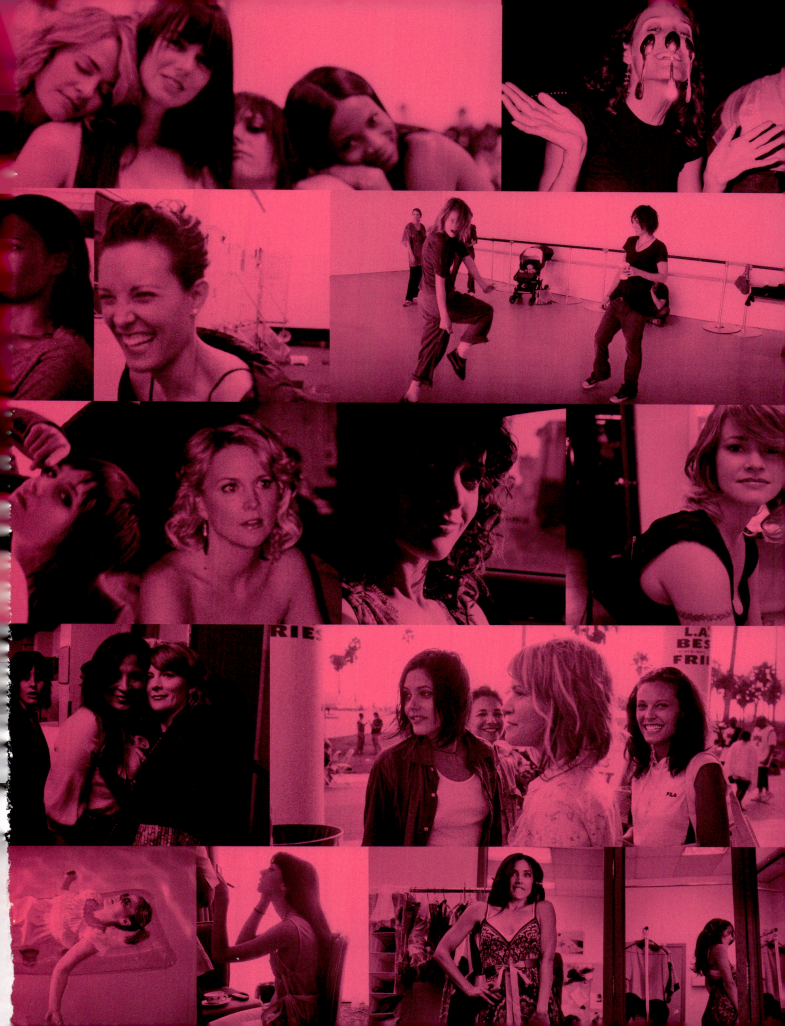